The Workboats of Core Sound

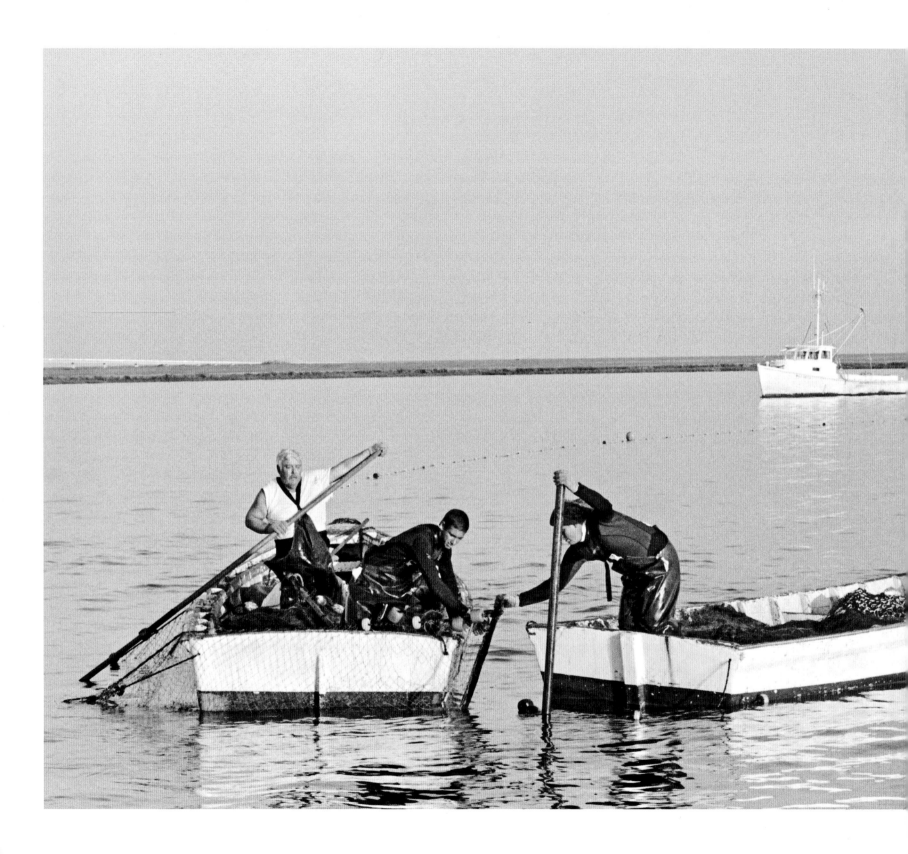

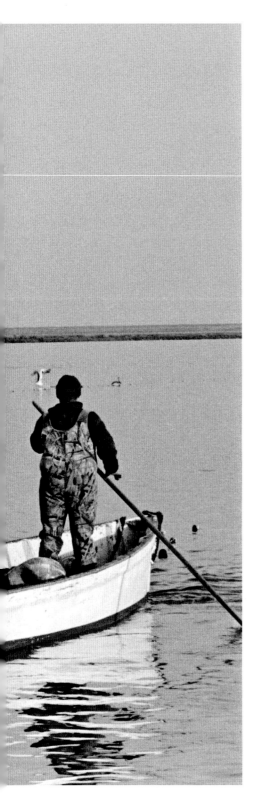

The Workboats of Core Sound

STORIES AND PHOTOGRAPHS OF A CHANGING WORLD

Written and photographed by Lawrence S. Earley

The University of North Carolina Press CHAPEL HILL

This book was published with the assistance of the Blythe Family Fund of the University of North Carolina Press.

© 2013 The University of North Carolina Press
Photographs by the author © 2013 Lawrence S. Earley
All rights reserved
Designed and set by Kimberly Bryant in Utopia and Helvetica Neue types. Unless otherwise credited, all photos are by the author. Glossary illustrations of Core Sound workboats by Michael Alford.

Manufactured in China

The paper in this book meets the guidelines for permanence and durability of the Committee on Production Guidelines for Book Longevity of the Council on Library Resources. The University of North Carolina Press has been a member of the Green Press Initiative since 2003.

Library of Congress Cataloging-in-Publication Data
Earley, Lawrence S.
The workboats of Core Sound : stories and photographs of a changing world / written and photographed by Lawrence S. Earley.
 p. cm.
Includes bibliographical references and index.
ISBN 978-1-4696-1064-1 (cloth : alk. paper) 1. Fishing boats—
North Carolina—Outer Banks. 2. Wooden boats—North Carolina—
Outer Banks. 3. Work boats—North Carolina—Outer Banks.
4. Carteret County (N.C.)—History, Local—Pictorial works.
5. Outer Banks (N.C.)—History, Local—Pictorial works. I. Title.
VM431.E26 2013
639.2′209756197—dc23 2013008284

17 16 15 14 13 5 4 3 2 1

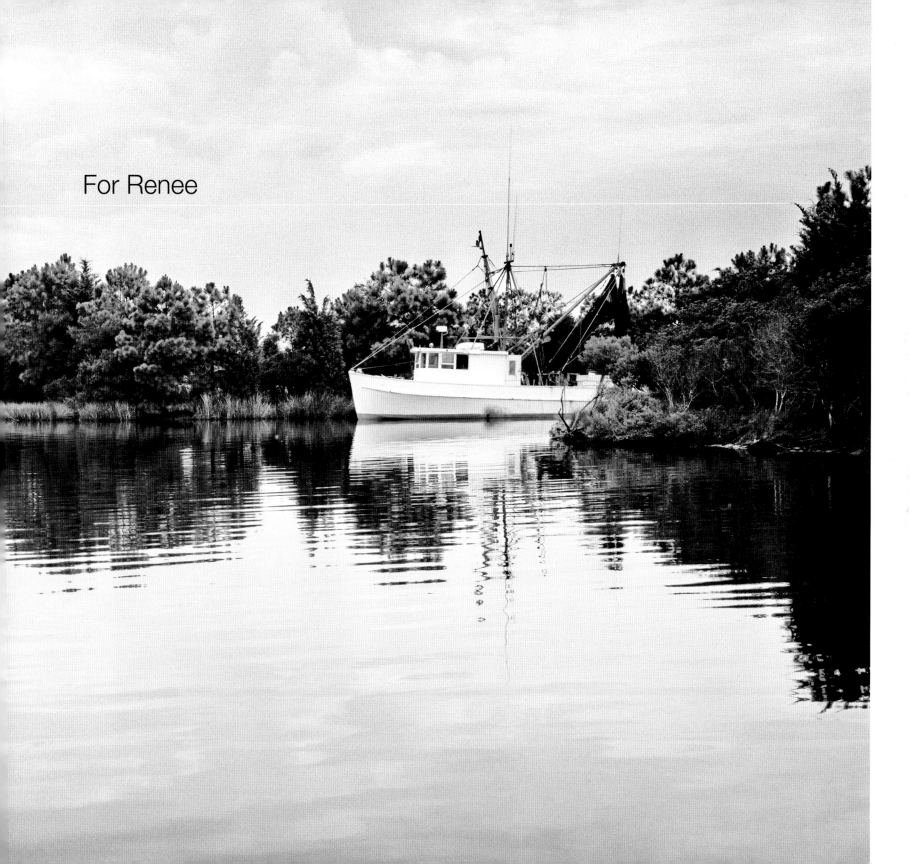

For Renee

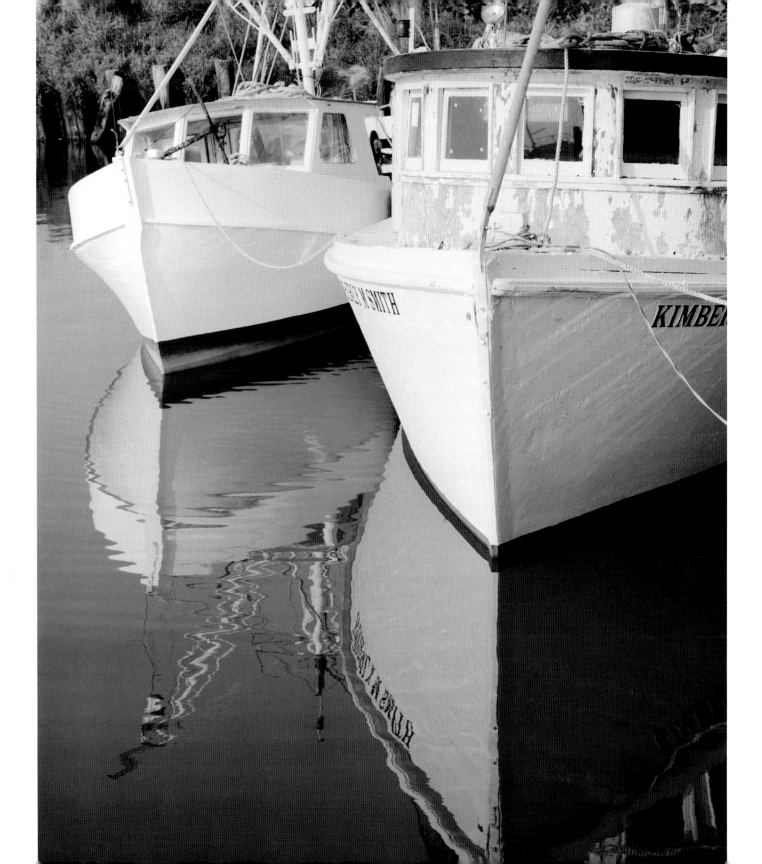

Contents

The Workboats of Core Sound

in a different sort of Conestoga. There were trawlers, skiffs, workboats of every size and shape, casually occupying a modest space up a narrow creek, beneath a bridge, in a canal just off the road, in a marsh off in the distance, or at a rickety wooden dock. Skiffs were tied to saplings driven into harbor mud. Boats leaned tipsily against pilings, and abandoned boats went to pieces in a marsh. Large boats on trailers peeked incongruously from behind houses. Workboats were as common as seabirds.

That was my first trip Down East. I returned several times over the following years, photographing boats and landscapes—or, to be more precise, boats *in* landscapes. In many ways, I hadn't yet begun to distinguish one from the other; they seemed so necessary to each other that a landscape without a boat seemed empty.

■ ■ ■ I did not appreciate then how a photograph can be a doorway into another world. Nor did I know that the act of making photographs would have such a profound effect on my own life, teaching me lessons about friendship and community, time and memory, pride and loss.

Here's what happened: In 2004, I exhibited about twenty photographs of workboats and landscapes at the annual winter waterfowl and art festival hosted by the Core Sound Waterfowl Museum and Heritage Center on Harkers Island, N.C. It's a relaxed, weekend affair, with dozens of artists and craftspeople exhibiting their wildlife paintings, decoys, and photographs, and thousands of visitors wandering through this grand gathering space for the Down East communities. One of the photographs in my exhibit drew more attention than I had ever imagined it would. It was a picture I had taken in 1985 of two fishing boats, one tied at a wooden dock behind a concrete breakwater and the other just returning from a fishing trip, trailing a skiff. On the deck of that boat, a fisherman coiled rope while another man moved on the bow. In the cabin, the unseen captain piloted the boat toward the docks. As simple as the photograph seemed, groups of men would stop in front of it and discuss it at length.

Of all the pictures I had chosen, I thought that one was the weakest and could have easily been omitted. It seemed only a snapshot, as opposed to other photographs that I had composed more carefully. I had even forgotten the name of the community where I had photographed it and had given it a somewhat generic title, "Workboats, Core Sound, 1985."

I finally asked one of the men why he was so interested in it. His name was Jimmy Amspacher, a boatbuilder from Marshallberg, and he told me that he was making a model of an old-style Core Sound workboat for a client and that the boats in the photo showed many of the features of the model he was building. He said the boat to the left was called *Linda*, the other one was *Wasted Wood*, and both were unmistakably built in the community of Atlantic. He told me that the boat was going to tie up behind Billy Smith's fish house in Atlantic. Both boats were built for "long-haul fishing," a common fishery in Atlantic. Even the three pilings in the open water told a story—

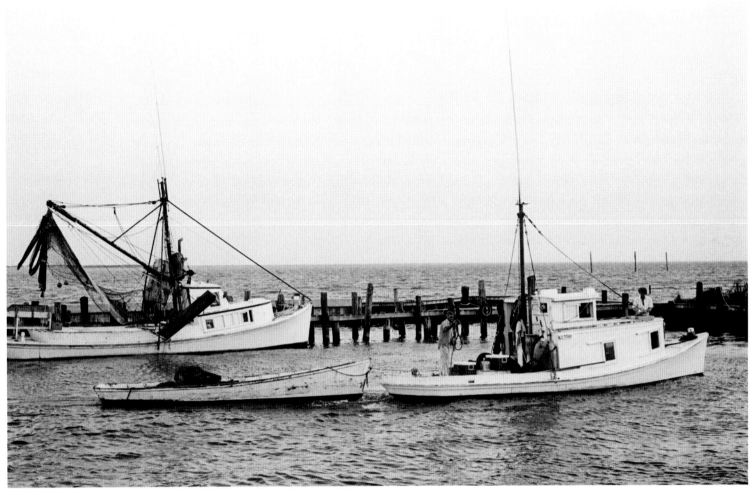

Linda and *Wasted Wood*, Atlantic, 1985

they once guided boat captains to Drum Inlet off in the distance.

Amspacher's reading enriched the photograph with its depth of documentary detail. What I had missed in the "simple" snapshot was its density of cultural meaning. Atlantic-style workboats? Long-hauling? Billy Smith's fish house? Drum Inlet? In a few sentences, Amspacher had lifted a curtain on a world that I knew nothing about—a world where boats were not just elements of a picturesque land-

scape but were rich in aesthetic, cultural, and technological information, where they sat at the center of a web of connections between individuals, families, and communities.

The photograph now had a new title: "*Linda* and *Wasted Wood*, Atlantic, 1985."

In the weeks after I returned from the museum, I thought about what I had learned about that photograph. At the time, I had been looking at a book called *Measure of Emptiness: Grain Elevators in the American Landscape*, by the photographer Frank Gohlke. Gohlke had photographed the grain elevators that occupied the mostly flat landscapes between the Appalachians and the Rocky Mountains. He saw them not only as objects of beauty in themselves, but also as leading to wider vistas of knowledge about the region as a whole. Arguing that grain elevators were part of the landscape, that they couldn't be considered in isolation from the landscape, he added this provocative statement: "Every element of a landscape participates in many networks of meaning, so that asking a simple question about a common object can open up the human history of an entire region."

I tossed all these ideas around in my head. Could I apply Gohlke's insight to my own work? After all, in Down East country, what was more commonplace than a fishing boat? And what could be a simpler question than "What can you tell me about this boat?" If I asked that question, where would it lead me?

I quickly sketched out a plan to photograph as many of Core Sound's old, wooden boats as I could find, ask questions about them, and see what the boats might tell me about the region's history and culture. Funded by grants from the North Carolina Arts Council and the North Carolina Humanities Council, and working in association with the Core Sound museum, I spent several years photographing Core Sound workboats and interviewing people from many Down East communities. In their homes, photographs traded hands—my 11-by-14-inch black-and-white prints and their 4-by-6-inch color prints in albums or rooted out from drawers in loose stacks. All became subjects of sometimes lengthy conversations that surprised family members who were listening in. "I never heard you talk so much about anything as you have today," said the wife of one boatbuilder after a particularly long session.

After spending seven years photographing the workboats of the region and listening to fishermen, boatbuilders, and their family members talk about the boats, I know much more about the world of "*Linda* and *Wasted Wood*, Atlantic, 1985." I know that I photographed these two boats on a Friday evening in September 1985 at the docks of Luther L. Smith Seafood Co. in the village of Atlantic, North Carolina. The round-sterned boat on the right, known as *Wasted Wood*, was built in 1933 by Will Mason of Atlantic for his son, Don, and named for its big timbers. In the 1950s, Don Mason sold it to Charles Smith of Atlantic, who renamed the boat *David M.* for his son, although most people continued to call it *Wasted Wood*. In 1979, Buster Salter of Atlantic bought the

boat for his long-haul fishing operation. The boat at left was *Linda*, also round-sterned. Boatbuilder Ambrose Fulcher of Atlantic built it for John Weston Smith in 1939. Smith named the boat for his daughter. In the early 1960s, he sold the boat to his brother, William (Billy) Smith.

When I look at the *Wasted Wood* today, I am aware of its long, low lines—what boatbuilders call a "sweeping sheer"—and I wonder at the audacity of watermen who worked so close to the water's surface. Both workboats have now "gone to pieces," as they say Down East about the final stages of a boat's life. Its owner abandoned *Wasted Wood* in the late 1990s, and Hurricane Irene finished off *Linda* in 2011. As early as the late 1970s, James Gillikin had built the bigger *Kathryn L. Smith* and *Kimberly M. Smith* to replace the old *Linda* for Billy Smith. While fishing at Drum Inlet in 1998, Smith drowned after his boat was capsized by a freak wave. The old wooden docks in the photograph are gone, too. Drum Inlet is shoaled up again, and the waters of the Atlantic Ocean are unreachable from Atlantic except by long passage southwest to Barden Inlet or northeast to Ocracoke Inlet.

The year that I made the photograph, 1985, was near the peak of extraordinary fishing success in Core Sound that had begun in the mid-1970s but was beginning a long decline from which it still has not recovered. During that time, up to a dozen or more six-man crews of long-haul fishermen from Davis to Cedar Island left their docks on a Sunday evening and fished in Core and Pamlico sounds or up the Neuse River, returning home on Friday evening for the weekend. Scores of shrimpboats left the little communities each evening from spring to fall to create a city of lights on the sound. Pound netters could make a living from the long pounds that they staked up and down the sound. Fishermen could also make money in winter kicking clams and dredging oysters out of the productive waters. Today many of those fishermen, young men at the time, are doing something else to make a living, if they've not retired, and their sons and daughters are wary about embracing the fishing life.

The world of the Core Sound fishermen and their workboats has changed a great deal since then. In some years, shrimping is rewarding and winter oystering can also make money, but commercial fishing in general has become more of a part-time endeavor for many fishermen.

"*Linda* and *Wasted Wood*, Atlantic, 1985" is only a single photograph of Down East's complex and varied fishing culture, but it haunts me today because of its intimations of change. The photograph evokes a moment in time when fishing offered Down East's sons and daughters a hard but decent working life, one very much like that of their fathers and grandfathers. The two wooden boats in the photograph are gone, and the traditional life of a Core Sound fisherman may be passing as well. The workboats of Core Sound tell many stories, but this is surely one of the most poignant.

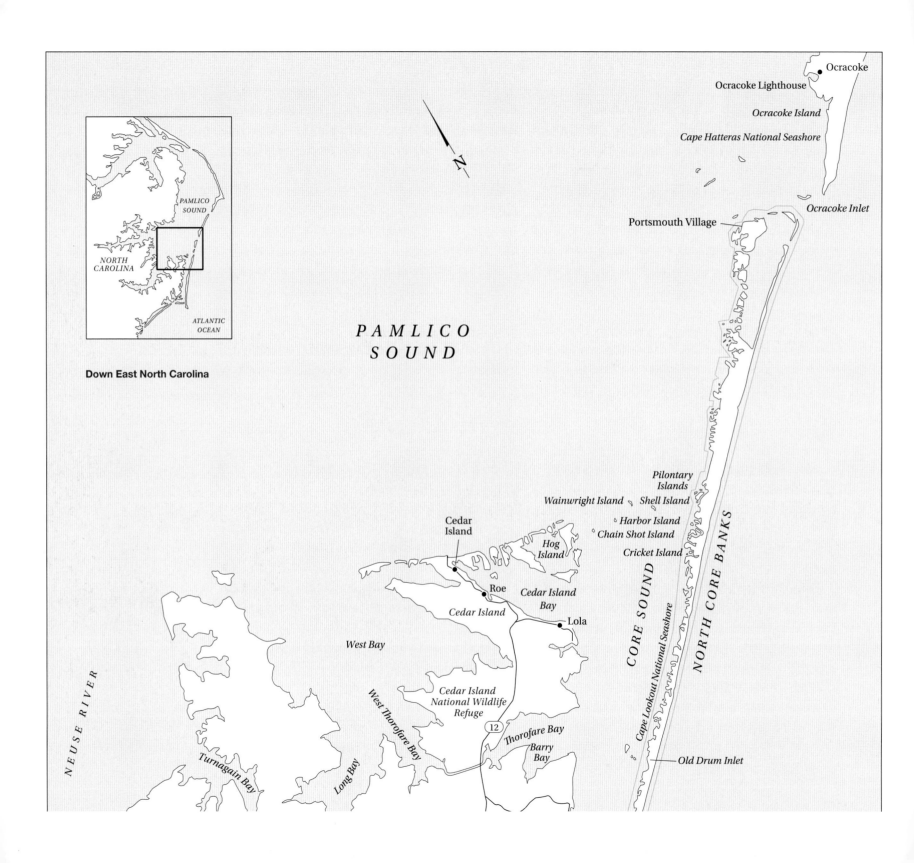

Ocracoke

Ocracoke Lighthouse

Ocracoke Island

Cape Hatteras National Seashore

Ocracoke Inlet

Portsmouth Village

PAMLICO
SOUND

Down East North Carolina

*Pilontary
Islands*

Wainwright Island *Shell Island*

Harbor Island

Cedar
Island

Chain Shot Island

*Hog
Island*

Cricket Island

Roe

*Cedar Island
Bay*

Cedar Island

Lola

West Bay

Cedar Island
National Wildlife
Refuge

12

Thorofare Bay

*Barry
Bay*

Old Drum Inlet

N E U S E R I V E R

Turnagain Bay

Long Bay

West Thorofare Bay

Thorofare Bay

C O R E S O U N D

Cape Lookout National Seashore

N O R T H C O R E B A N K S

PAMLICO
SOUND

NORTH
CAROLINA

ATLANTIC
OCEAN

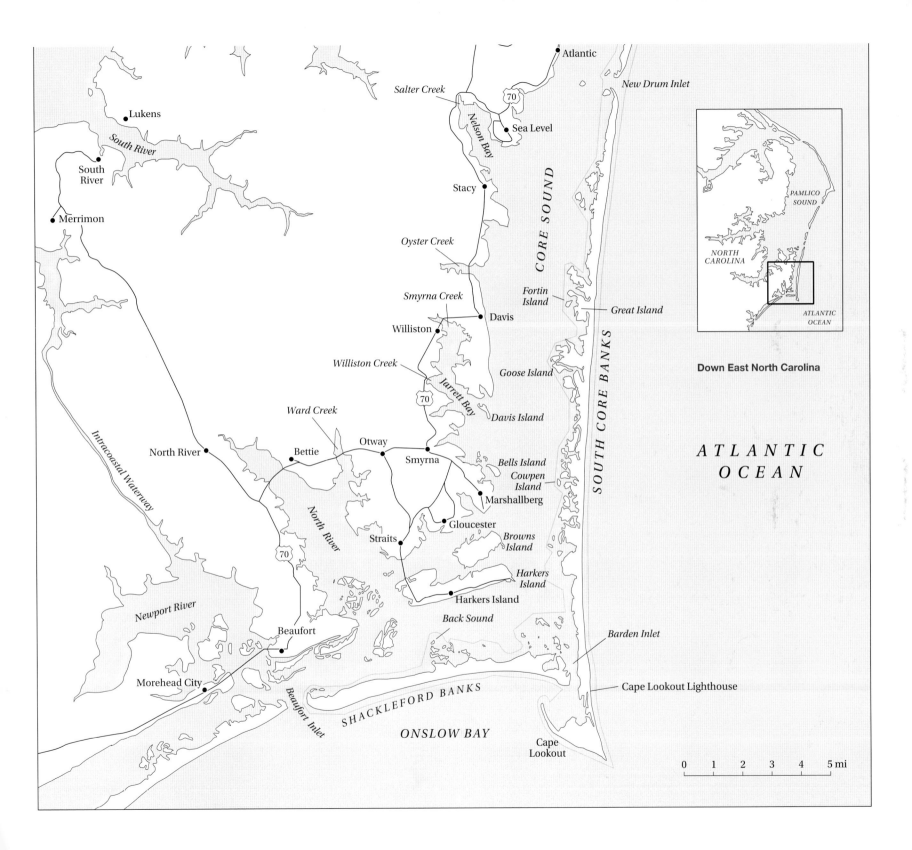

Atlantic

Salter Creek

70

Lukens

South River

South
River

Sea Level

Nelson Bay

New Drum Inlet

Merrimon

Stacy

C O R E S O U N D

Oyster Creek

*Fortin
Island*

Great Island

Smyrna Creek

Davis

Williston

Williston Creek

Goose Island

Jarrett Bay

70

Davis Island

Ward Creek

Otway

Bettie

Smyrna

Bells Island
*Cowpen
Island*

Marshallberg

North River

North River

70

Gloucester

Straits

*Browns
Island*

*Harkers
Island*

Harkers Island

Intracoastal Waterway

Newport River

Back Sound

Barden Inlet

Beaufort

S O U T H C O R E B A N K S

Morehead City

Cape Lookout Lighthouse

Beaufort Inlet

S H A C K L E F O R D B A N K S

O N S L O W B A Y

Cape
Lookout

A T L A N T I C
O C E A N

*PAMLICO
SOUND*

*NORTH
CAROLINA*

*ATLANTIC
OCEAN*

Down East North Carolina

0 1 2 3 4 5 mi

Down East, at the Water's Edge

"Down East" North Carolina refers to the wet peninsula lying east of Beaufort, in coastal Carteret County, with its broad skies, extravagant marshes, shallow sounds, and notched bays. It's a somewhat ambiguous designation, not only because of its long association with the state of Maine, but also because it's so often misused in North Carolina. Politicians, reporters, and TV announcers regularly use "Down East" as a synonym for eastern North Carolina in general. But for the people who actually live there, you're Down East only after you take N.C. 101 from Havelock or U.S. 70 from Morehead City and Beaufort and cross the North River. *Period.*

From there, a two-lane highway wanders in a northeasterly direction through a dozen or so small communities from Bettie to Cedar Island, flanked on the west and north by the broad mouth of the Neuse River and the vast inland sea of Pamlico Sound, and on the east by Core Sound, the Core Banks, and the Cape Lookout National Seashore. Like North Carolina's other sounds, Core Sound is a shallow lagoon, about 20 miles long, 2 to 6 miles wide, and not much more than 10 feet at its deepest. Core Banks is a narrow spit of sand 40 miles long bracketed by Cape Lookout Lighthouse at one end and, at the other, the village of Portsmouth, founded in 1753 and once an important port of entry, then a fisherman's village, and now part of Cape Lookout National Seashore. Between Cape Lookout and Portsmouth, three periodically open inlets—Drum Inlet, Swash Inlet, and Whalebone—grant unreliable access to the Atlantic Ocean. Between Portsmouth and Ocracoke Island lies Ocracoke Inlet, where Blackbeard sheltered his piratical enterprises. Immediately to the north of Ocracoke is Cape Hatteras, and stretching all the way to Virginia are Cape Hatteras National Seashore and the northern Outer Banks.

Most of Down East is wet. The water is shallow; the soil, thin. Yet, for such a sea-girt land, Down East was once heavily wooded with maritime forests and longleaf pine on the higher, sandy ridges. In some places, it still is. Mosquitoes lay claim to bare skin in this waterlogged land about every month of the year. Hurricanes regularly punish the villages with wind and flood.

The people built their homes along the shore or on a piney ridge with access to the sound via creek or ditch—there are fifteen named creeks on the penin-

My granddad said when he was a boy, they were lucky to have some sort of sail rig so they could move from village to village on the water. He said it was possible that if you were to take out through the wilderness just between Atlantic and Smyrna, you'd never make it. You'd never be heard of after that because it was an impossibility to move through the wilderness. So they'd just go down to the water's edge and step aboard their rig and they were on their way.
—James Allen Rose, Harkers Island

My grandmother was a Mason but she married a Smith; her sister Melinda was a Mason and a Nelson, and she married a Smith. So all that crowd at that end of Atlantic are Smiths related to my grandmother or to her sisters. My father's mother was a Nelson. Once you left Highway 70 in Atlantic you were basically in Nelsontown first, and then when you went around a couple of curves you were in Smithtown. All the houses were Smiths and they were all related, brothers and sisters and aunts and uncles. And then on the other side of town, you had Morrises and Salters.
—Elmo Gaskill, Atlantic

sula. They fished mainly, but they also grew their own food, raised and slaughtered cattle and hogs, kept fruit trees and honeybees, and wove their own cloth from the wool of their sheep. They traded for staples. They opened net shops, fish houses, millinery stores, grocery stores, gristmills, and later, a movie theater or two. They built boats and repaired them. Despite the isolation of the villages, a fisherman from Atlantic might tie up at a Harkers Island dock, see a pretty girl, and eventually bring her home. A Cedar Island pound netter might land a teacher from Stacy.

The fishermen were far-traveled, fishing in the inshore waters of Core Sound and Pamlico Sound and up the Neuse River and, some of them, working the deeper waters of the Atlantic. They sold oysters in the North Carolina port towns of New Bern, Washington, and Edenton and in Norfolk, Virginia. They sold flounder in Boston, Massachusetts, and scallops in Cape Canaveral, Florida. They shrimped off Florida and worked on menhaden boats from Cape May, New Jersey, to the Gulf of Mexico. They might have seen more of the country than most North Carolinians.

Well into the twentieth century, the scarcity of paved roads and bridges continued to isolate the communities from one another. U.S. 70 from the North River to Atlantic was completed in 1930. Harkers Island's road, once an oyster-shell-paved path, got a hard covering in 1936. Cedar Island's road wasn't paved until 1948. Before you could drive across some

of the early bridges, you might have had to straighten out the loose boards. One Davis resident recalled that her great-aunt refused to ride in a car across the bridge between Williston and Davis; she felt safe only when she walked across the bridge. The Monroe Gaskill Memorial Bridge, the last of three bridges carrying N.C. 12 to Cedar Island, was completed in 1995. The previous drawbridge had a weight limit, so Cedar Island children on their way to school in Atlantic got out of their bus and crossed it on foot. "I've been told that some of the children would go under the bridge and hide," said Elmo Gaskill of Atlantic. "They'd play all day and then when the kids returned from school, they'd join them and get back on the bus to go home."

Before the roads and bridges, the twice-daily mailboat from mainland Beaufort linked the villages, stopping at Harkers Island, Cape Lookout, Gloucester, Marshallberg, Davis, Sea Level, Atlantic, Hog Island, and Portsmouth. The mailboat carried passengers and freight as well as mail. Passengers could board the mailboat in Beaufort at 8:00 A.M. and expect to reach Atlantic by noon.

■ ■ ■ In April 2006, I rented an apartment in the community of Atlantic and spent nearly a week each month there for the next eighteen months and continued to spend time there for several more years. I chose the community as my base because I liked it and because it had an exceptional number of older boats. Just beyond the Daniel E. Taylor Memorial Bridge over Salter Creek, U.S. 70 veers to the right, passing the community of Sea Level and cross-

ing Styrons Creek, one boundary of the community of Atlantic (the other is Hall Point). Here, for many years, you'd be greeted by a sign that said, "Atlantic—Living from the Sea." Settled in 1740, Atlantic was incorporated in 1905, not so much out of civic zeal but to fulfill rules for establishing its high school, the first public high school in Carteret County. The elected officers of the town consisted of a mayor, three aldermen, and a marshal, but after John D. Smith served as mayor from 1916 to 1920, no other person ever held the office. Atlantic's prevailing ethos is still the old independence of spirit that led its founding citizens to this spot almost 300 years ago.

In the eighteenth century, when Blackbeard and his pirate band anchored off Ocracoke, at the northeastern end of Core Sound, Atlantic didn't exist as such. It was part of a territory known as Hunting Quarters that encompassed Sea Level and extended all the way to Stacy. The colorful name suggests an era of pirates and Indians and fishermen. With the establishment of post offices, new town names replaced the wider designation. Atlantic took its present name in 1890.

In his interesting little history, *Growing Up Down East and Other True Stories*, Atlantic native Elmo Gaskill Jr. notes that the 1800 census of Hunting Quarters listed nineteen people whose surnames were Styron, Hamilton, Gaskins, Robinson, Hill, Dickson (Dixon), and Wallace. A year later, four new names were added: Mason, Roberts, Ross, and Gaskill. If Fulcher, Salter, Nelson, Hamilton, Gilgo, Morris, Smith, Willis, and a handful of other names were

added, you would have a pretty good roster of today's native Down East families. (The first elected officials in Atlantic included two Hamiltons, a Morris, a Willis, and a Mason.)

Highway 70 hugs the shoreline through Atlantic, with Core Sound visible through the trees. The comfortable-looking houses sit far back off the road behind long expanses of lawn overtopped by scatterings of pine trees. Behind the houses, on the landward side, is a continuous forest of tall pines. Entering the commercial district, marked by the Red and White Grocery, you pass what seems to be the old town, where the houses are older and situated closer to the road. The highway, now called Seashore Road, runs parallel to Shell Road, an older road once paved with oyster shells. In between these two roads are residential lanes that curve like the twine of loose netting, and off these lanes dirt paths twist past other clusters of houses. Flanking the grocery is a road that leads to Atlantic Field, a Marine Corps outlying field. In the late winter, fishermen once dried their freshly tarred nets on the cracked tarmac.

Just beyond the town's main cemetery on Seashore Road is the Atlantic Fire Department, site of the old Atlantic Theater. During World War II, the army, navy, and Marines operated out of Atlantic, and the town experienced a population boom for a couple of decades. Besides the Atlantic Theater, residents recall five or six stores, a dance hall, and a restaurant or two. In its heyday, they say, Atlantic was a booming small community, among the most prosperous rural communities in eastern North Carolina. The town prided itself on the number of high school graduates it sent to college. The ferry to Ocracoke Island left from Atlantic until the mid-1960s, and vacationers crowded the road in summer to reach the ferry. The town's luster dimmed a bit with the relocation of the ferry dock to Cedar Island. Under school consolidation, Atlantic's high school closed in 1965, and the students are now bused to Beaufort. The theater closed, and soon most of the other commercial venues were gone as well. The last of them, Winston Hill and Sons, a general store, closed in the 1970s. Its deteriorating wooden structure remains adjacent to the recently closed Clayton Fulcher Seafood Co.

Atlantic is the terminus of U.S. 70, or its beginning, depending on how you look at it. It dead-ends at the county harbor where the boats are docked and where a sign once announced, "Los Angeles, 2700 miles," and where I once had the following conversation with a fellow who drove up, stopped, and stuck his head out the window:

"Excuse me, sir, can you tell me how to get out of here?"

"Where do you want to go?" I asked him.

"Back to civilization," he said.

I knew what he meant, although I wouldn't have put it exactly that way. There's a hard edge beneath the soft texture of Atlantic, a down-at-the-heels, we've-had-better-days quality about the "downtown," for sure. Atlantic is not a tourist town. It offers few social amenities, with no coffeehouse, diner, or sit-down restaurant where folks can gather and drink a beverage or two. A grill on Morris Marina Road ca-

ters to the sports fishermen taking the ferry across Core Sound to rental fishing camps on Core Banks. Locals also go to the grill to eat the good burgers and sip a beer. The White Point Grill, located on the other side of the Atlantic harbor, offers take-out food. When fishermen and their families want to eat dinner at a fancier restaurant, they drive 8 miles to Cedar Island to eat at the Driftwood Motel, or 30 miles to Beaufort or Morehead City on the mainland.

Atlantic's main public places have always been the two churches, the United Methodist Church and the Atlantic Missionary Baptist Church, from whose steeple on Wednesday prayer nights you will hear the carillon playing "Stand Up, Stand Up for Jesus" and "Come, Thou Almighty King." The two big fish houses, Luther L. Smith & Son, Inc., and Clayton Fulcher Seafood Co., also offered daily social opportunities, and when the fishing was good, the fish houses were really the beating heart of Atlantic's economic life, where you could feel the place at its liveliest. That was mainly true some decades ago when Atlantic's fishing fleet numbered about seventy-five boats and they would line up to unload their catches at the fish houses.

Even now, at the end of a summer or fall day in Atlantic, with a single boat at the Smith fish house, you can feel the excitement that once surrounded the arrival of several fishing boats. On the dock, old-timers and a few visitors mingle to inspect the haul. Hispanic workers shovel fish from the boat's hold onto a conveyor belt that carries them inside the fish house, where they are sorted by several African American men and women. Small fish, most often spots, go into the iced cardboard boxes that have been prepared ahead of time. Bigger fish are sorted by species. A front-end loader moves the packed boxes to a waiting truck that will take the fish to market.

Whenever I drove to Atlantic, I always stopped first at the Smith fish house. Smith Seafood is one of only two places Down East that still have a marine railway so fishermen can haul their boats out of the water for repair or a paint job. Once out of the water, a boat's lines are cleanly visible and make good photographs. I have photographed *Haulboat*, *Old Salt*, *Hazel*, *Kathryn L. Smith*, *Kimberly M. Smith*, and other boats there. Behind the fish house, half a dozen boats were frequently tied up, and I photographed them at their slips. *Hazel* was there and derelict *Linda* as well, although from 2007 until 2011 *Linda* was gradually sinking. I photographed the boat floating on the water, submerged to the deck after its bilge pumps failed, and buried below the pilothouse. In 2011, a piece of rigging was all that remained of *Linda* in the aftermath of Hurricane Irene.

I organized my days Down East around scheduled interviews and photography, photographing in the mornings and late afternoons, when the boat hulls glowed in the sunlight. I spent many mornings at Atlantic Harbor, inspecting the white workboats tied to the wooden docks, their bows facing out. The decks of workboats tied up at the harbor sometimes look like a teenager's bedroom, strewn with sneakers and boots and waders and shirts and socks and gloves. A fisherman's gear tends to get rusty or run-

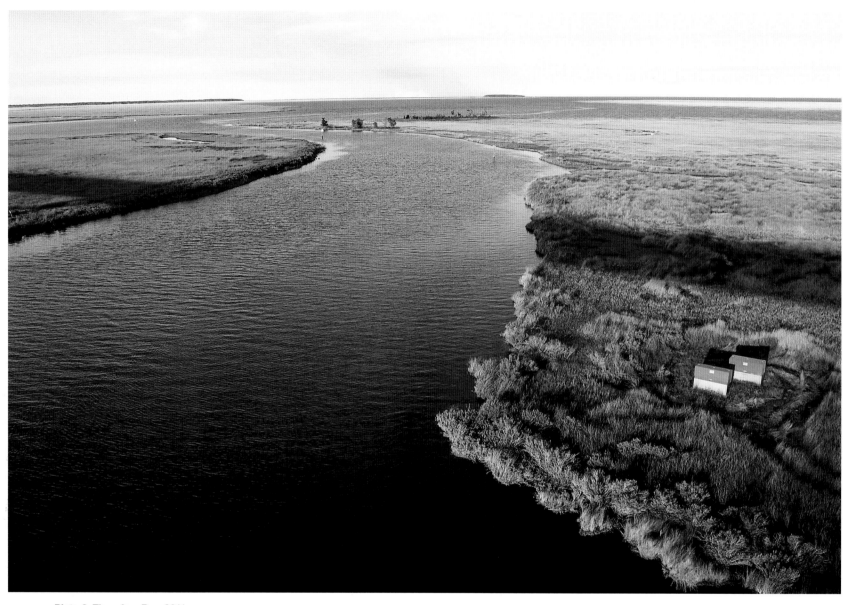

Plate 2. Thorofare Bay, 2011

Before the Thorofare was there, fishermen here had to go all the way out Harbor Island, out the channel there, to go up to New Bern [on the Neuse River], over to Little Washington [on the Pamlico River], and even to Edenton [on the Chowan River]. That's where they sold their oysters in the wintertime. They traded up there. That was back when they would go get flour in barrels. Barrel of flour, a barrel of this and a barrel of that. And they would sell their oysters or maybe trade them—so many pounds of oysters for so many barrels of flour and other commodities.
—Elmo Gaskill, Atlantic

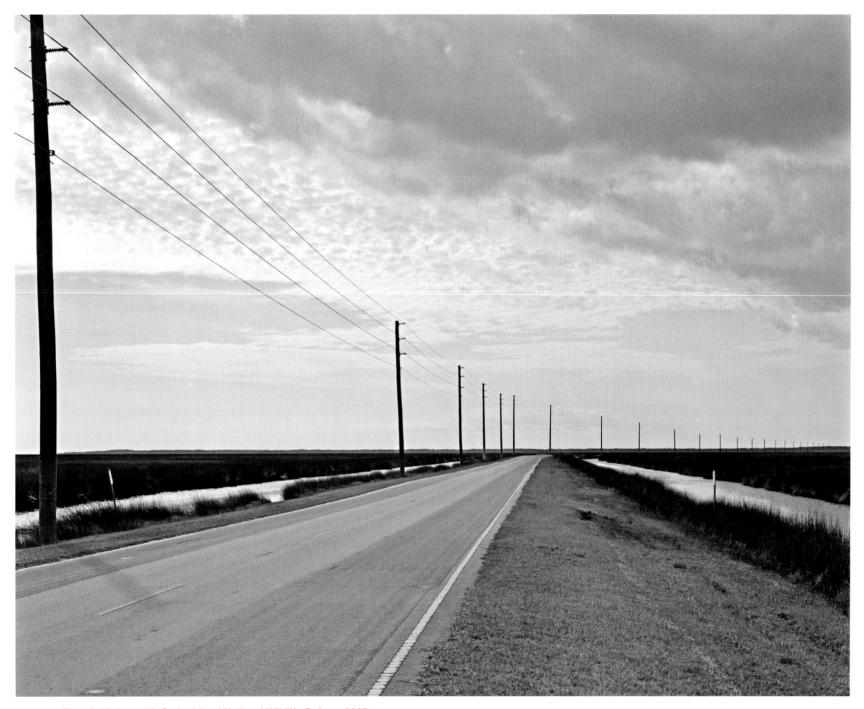

Plate 3. Highway 12, Cedar Island National Wildlife Refuge, 2007

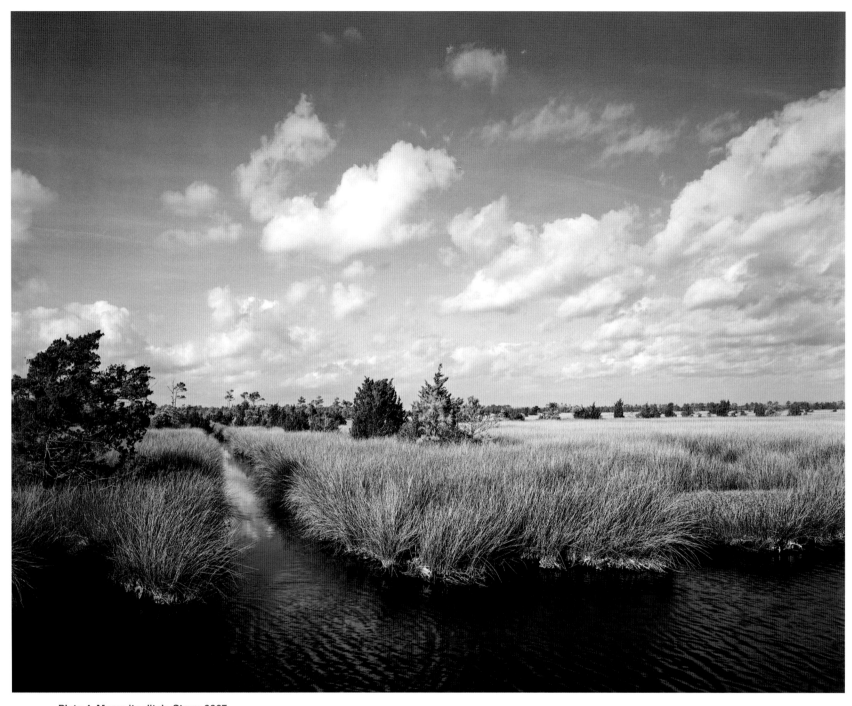

Plate 4. Mosquito ditch, Stacy, 2007

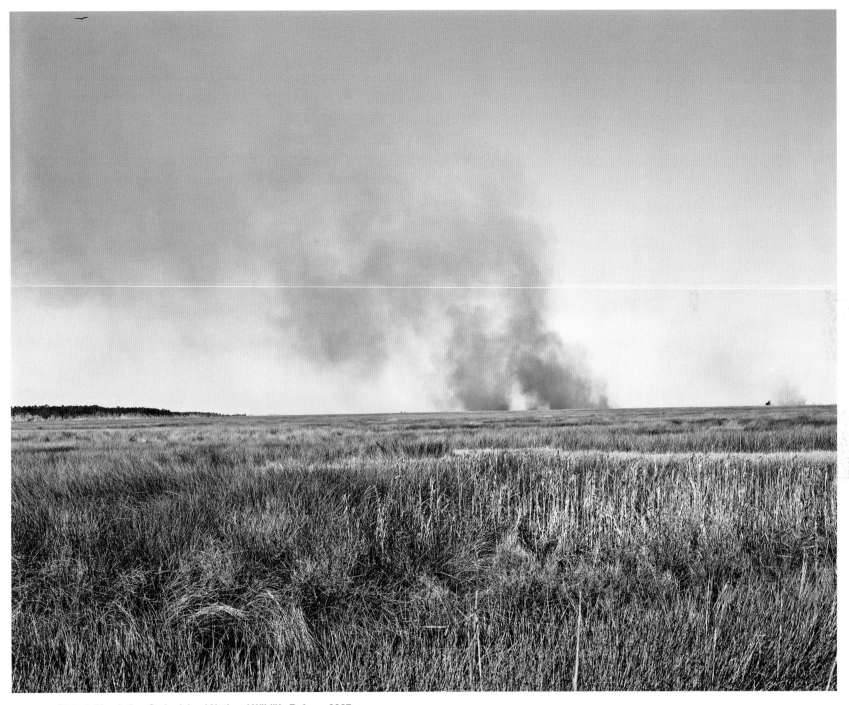

Plate 5. Marsh fire, Cedar Island National Wildlife Refuge, 2007

Plate 6. Juncus Marsh, Davis, 2007

Plate 7. Down East, 2007

So they had sheep and pigs and cattle and horses and goats all running around, free. And everybody had their own little garden and they grew collards and onions and potatoes and corn, and then they would kill a hog or something and they would distribute the meat around among the family members. Back in the late forties, they would have a hog killing and they'd kill several hogs at the same time. They took a fifty-gallon barrel and dug a hole in the ground at an angle and put a barrel in it. After they shot the hog they'd put hot water in that barrel and put the hog in it. Then they'd pull him out and put him up on some boards and a crowd would get around with different brushes to get the hide off him. They made all kinds of things. They made chitlins, hogshead cheese, pigs feet. Nothing went to waste.

—Elmo Gaskill, Atlantic

When people die, I don't send flowers.
I bake a ham and bring it to the house.
Some weeks I bake five hams; some
weeks only one ham. This week I didn't
bake a ham.
—Janice Smith, Atlantic

Plate 8. Stacy Cemetery, 2007

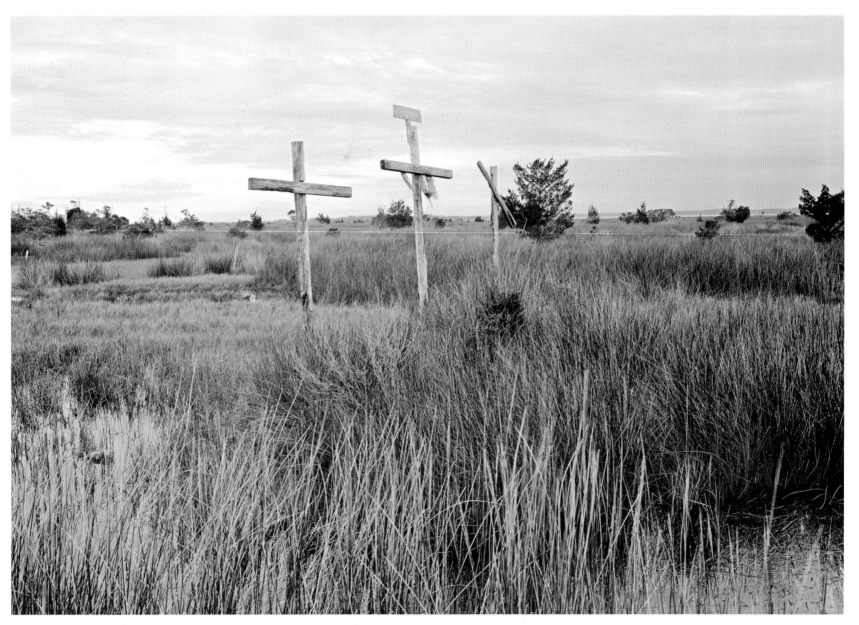

Plate 9. Davis, 2006

23

Plate 10. Sea Level, 2006

24

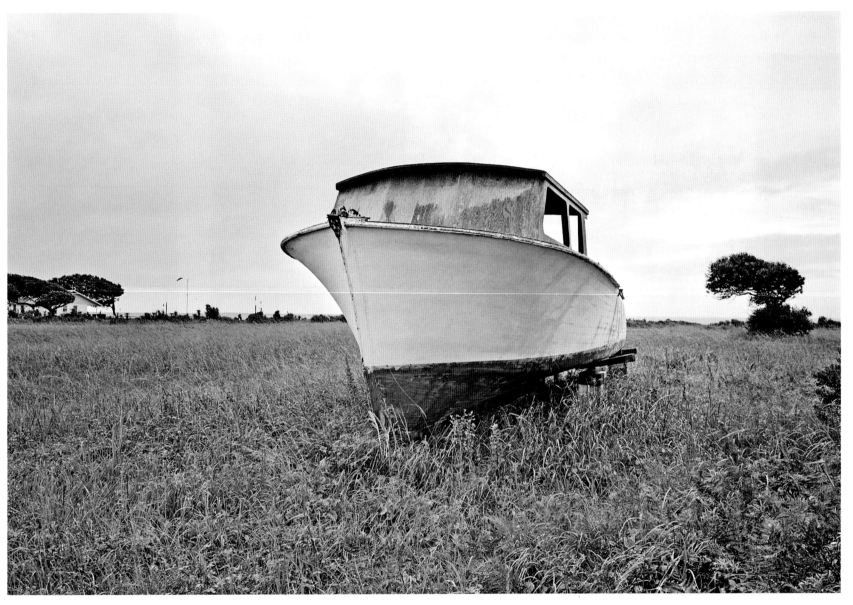

Plate 11. Harkers Island, 1995

I can remember the last ones at Harkers Island. Howard Gaskill was a great fisherman there. He was one of the last ones I know to wear a sou'wester. You know that old sou'wester hat? He wore a sou'wester. I can see him with his head stuck up through the hatch coming into Harkers Island. He was a big guy, smoked a pipe. He's just like these pictures you see up in Maine or somewhere. He was a tough fisherman, a good fisherman. He was a big man and I can see him now, smoking that pipe with his head stuck up through the hatch. I can see him now.
—Clay Fulcher, Atlantic

Plate 16. Maritime forest, Atlantic, 2006

Plate 17. Hidden house, Atlantic, 2007

Plate 18. Hunting Quarters Primitive Baptist Church, Atlantic, 2006

I used to go to the Primitive Baptist church with my grandmother who was a Primitive Baptist. And I remember that beautiful crystal water pitcher with a big hunk of ice in it. And when you go, you go at 11 o'clock and sometimes it was 4 o'clock before you got out of there. And every once in a while, Mr. Gray, the pastor, he would pour him some water, and I'd say, "Mama Alice, I certainly could use some of that water." And she'd say, "Honey, we'll be out in just a little."

 You know the way they paid him? They put their money in the palm of their hand, and when he shook hands with them he'd take the money. They didn't take up a collection or anything like that.
—Janice Smith, Atlantic

Plate 19. Leonard Goodwin's pound net, Atlantic, 2006

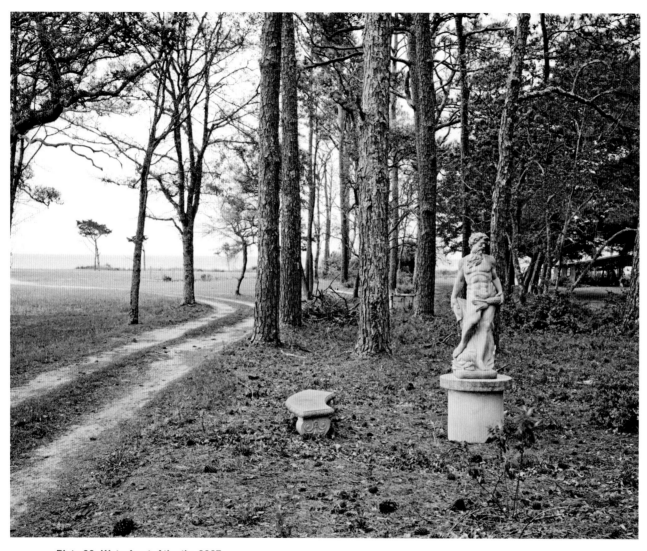

Plate 22. Waterfront, Atlantic, 2007

Plate 23. *Miss Kailyn* coming in, Atlantic, 2006

A lot of our boats went to Norfolk. One man left aboard a boat named the *Louise*. She was built in the early twenties probably. But he went to Norfolk and kept her tied up to the Atlantic Ice Company, right where the ferry crossed from Portsmouth to Norfolk, East Main St. And I'd take shrimp there to be frozen in the fall and he got to be a very good friend of mine. He stayed in Norfolk twenty years on the *Louise*. He kept her up and painted her. And when he came back to Atlantic he walked across the road to his wife's house and said, "What're we having for supper?"
—James Paul Lewis, Davis

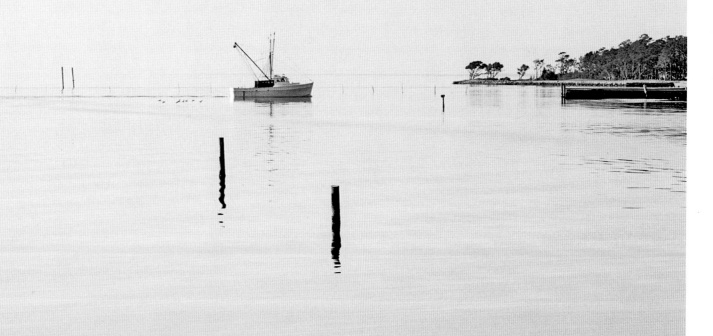

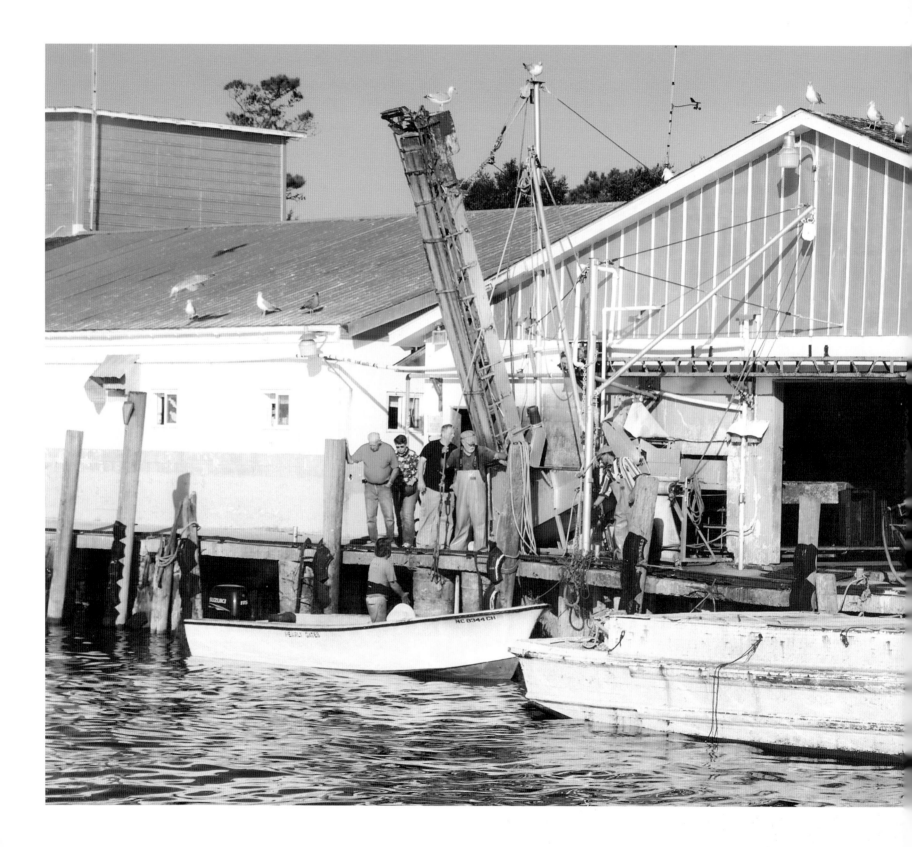

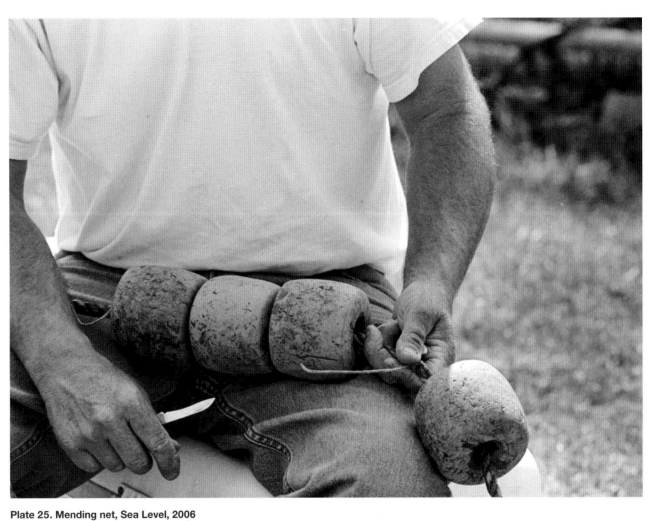

Plate 25. Mending net, Sea Level, 2006

Plate 24. Smith fish house, Atlantic, 2011

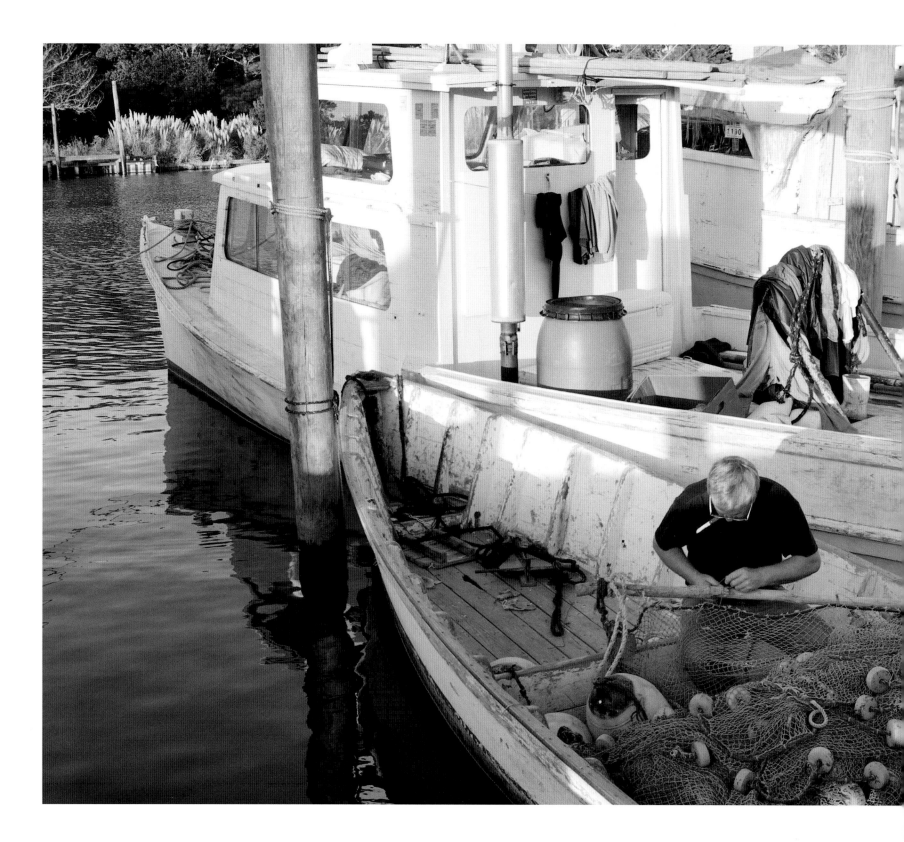

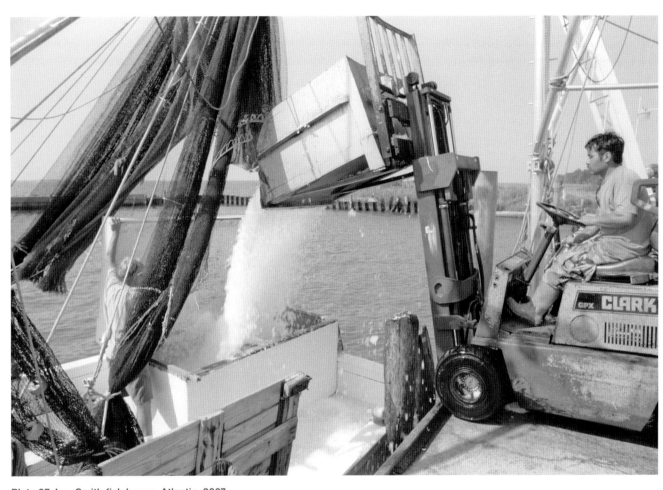

Plate 27. Ice, Smith fish house, Atlantic, 2007

Plate 26. Mending net, Atlantic, 2010

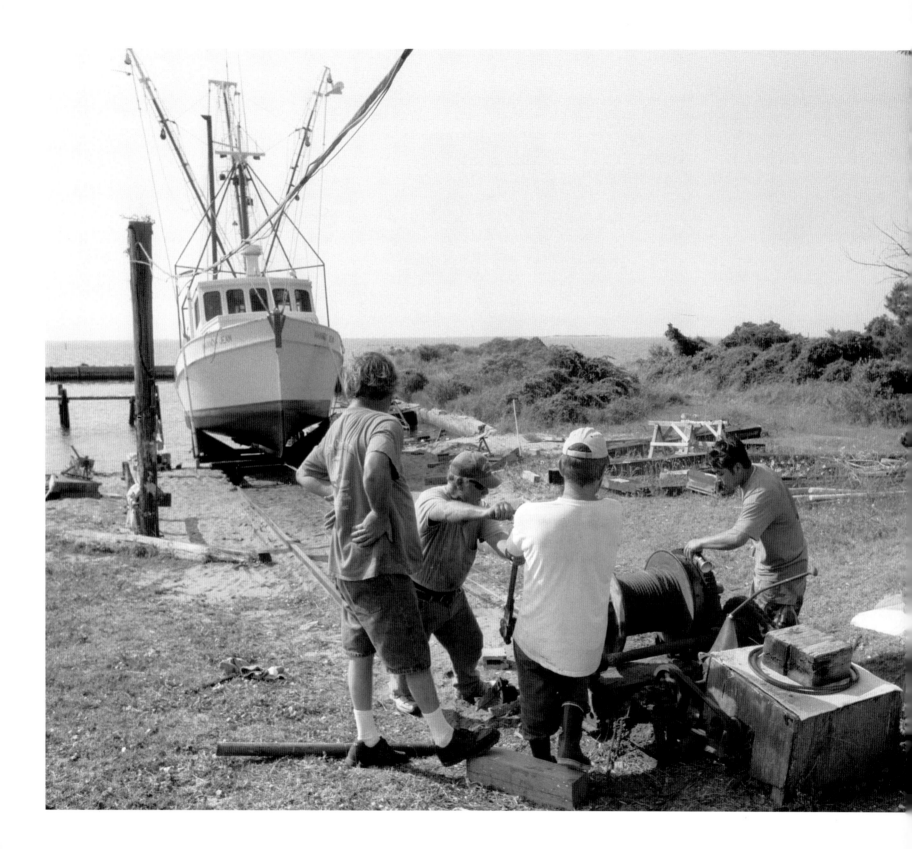

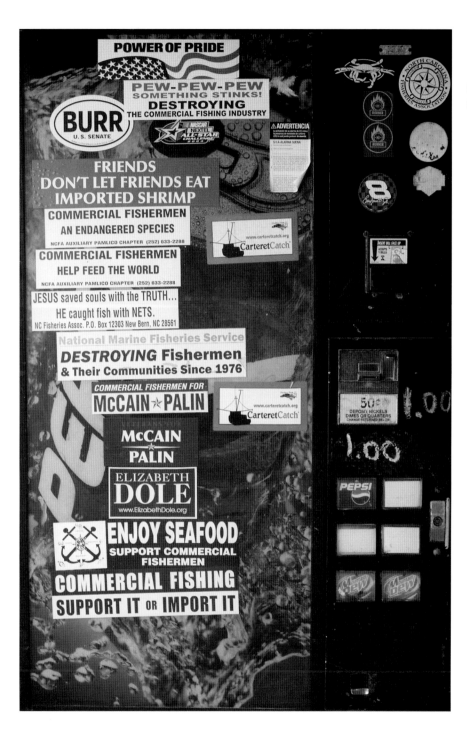

Plate 29. Drink machine signs,
Smith fish house, Atlantic, 2011

Plate 28. Hauling *Amanda Jean* onto railway,
Smith fish house, Atlantic, 2007

Plate 30. Clayton Fulcher Seafood Co., Atlantic, 2007

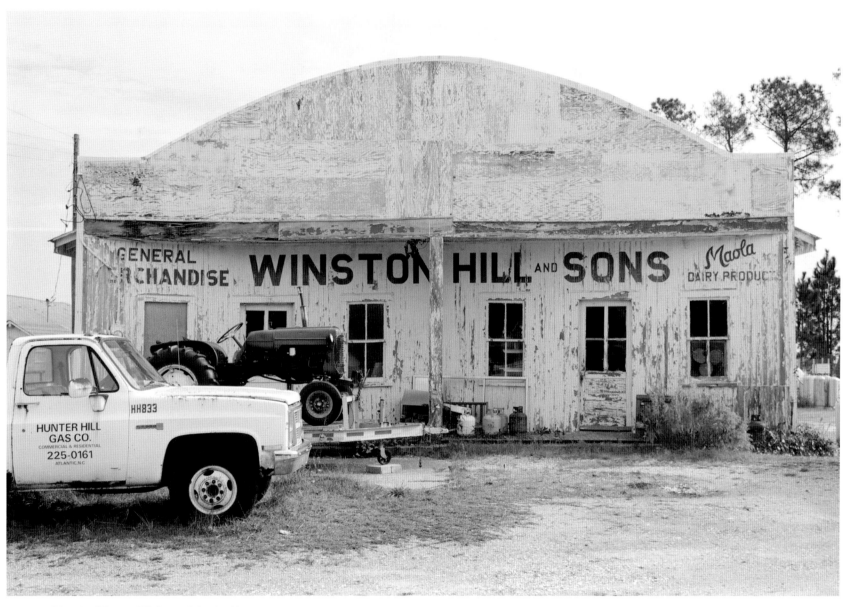

Plate 31. Winston Hill Store, Atlantic, 2011

Deadrise and a Sweeping Sheer

Whether it was the log canoes of the colonial era, the elegant sailing sharpies of the nineteenth century, or the Core Sounders of the twentieth century, Down East boatbuilders have built all kinds of boats to exploit the exceptional variety of fisheries in these waters. A twentieth-century fisherman, for example, might have to haul nets for fish, work a pound net, set a sink net and crab pots, dig clams, dredge or tong oysters, and drag shrimp nets—some in the same season and almost all in the same versatile boat. And a boat had to be perfect in at least one respect—it had to float in shallow water.

Older generations of Core Sound boatbuilders used memory and experience rather than plans or blueprints to guide their hands, and there are some that still do. The local expression for this kind of intuitive boatbuilding is "by the rack o' the eye." They went into local forests to cut trees for their boats—often old-growth longleaf pine for the keel, knees, and frames, and Atlantic white cedar (locally called "juniper") for the planking. They built the boat under a tree in their backyard and enlisted neighbors and friends to help them roll it into the water when they were done. An exaggerated claim is that you could take a boy from Harkers Island to New York City for a decade or so and when he returned he could build a wooden skiff without a plan.

The demand for wooden boats has declined over the years. Boatbuilding today requires a new set of skills, and new materials—composites, molded plastics, laminates, computer programs. Wooden boat aficionados turn up their noses at these space-age technologies. "You *manufacture* one of those boats," they say. "You *build* a traditional Core Sound wooden workboat."

Modern workboat evolution in Core Sound began with the arrival of the sailing sharpie in the 1870s. The nautical historian Howard I. Chappelle noted that though North American boatbuilders fashioned as many as 200 different types of small sailing vessels over the years, only a few were successfully transplanted to other locations. One of these adaptable boats was the sailing sharpie. It originated in New Haven, Connecticut, where oystermen used it, but then it migrated south, where it flourished. The sharpie had a flat bottom with planks laid from side to side rather than fore and aft. Its hull was narrow and straight-sided, with a low freeboard and a dis-

I don't know anybody who has ever built a perfect boat. 'Cause there's somewhere on that boat that don't work right. She might run fast, but as soon as she gets in a sea she wants to slide around on you, she don't want to work good, she don't want to pull right, she draws too much water. There's no such thing as a perfect boat.

—Jimmy Amspacher, Marshallberg

tinctive round stern. It measured anywhere from 25 feet to more than 40 feet long and could just about float in a washtub. It was easy to build and didn't cost much.

Michael Alford, a former curator at the N.C. Maritime Museum in Beaufort, says the sharpie's capabilities in shallow water made Core Sound the boat's stronghold. In the years following its introduction, North Carolina boatbuilders continually tinkered with the sharpie design, developing several versions. But with the application of gasoline engines to boats in the early twentieth century, the flat-bottomed sharpie hull gave way to a "deadrise" or V-shaped bottom, planked fore and aft, a hull shape that accepted a motor and handled rough water well. These Core Sounders, as they were called, still retained many of the features of the old sharpies—long and narrow hulls, a low and sweeping freeboard, and a round stern. By the 1920s and 1930s, most of the new boats were engine-powered in the mold of the Core Sounder.

This is not to say that there was a single type of Core Sounder. Core Sound vessels shared many characteristics, yet subtle differences among these boats reflected the creativity of the builders, the boatbuilding traditions of the community in which they were made, and the fishing for which the boats were built. Little boys in Down East communities grew up drawing boats, and they learned the aesthetics of good workboat design when other little boys made fun of their drawings. Some of these boys grew up to be recognized for their ability to put wood together, and

a few achieved legendary status. Among them were Stacy Guthrie, Devine S. Guthrie, Julian Guthrie, Brady Lewis, Clem Willis, and the Rose brothers, all of Harkers Island; Mildon Willis and sons Grayer and Kenneth of Marshallberg; Elmo Wade of Williston; Ed Willis of Sea Level; Ambrose Fulcher, Henry Fulcher, and Dennis Robinson of Atlantic; and Carl and Charley Edwards of South River. There were many others as well.

■ ■ ■ When I first arrived in Atlantic, I found a number of old wooden workboats in the harbor or in the protected waters behind the fish houses. Many of them had been built in the 1970s and 1980s, but others were ancient in comparison. *Old Salt* (formerly *Aileen*) was built in 1919; *Hazel*, in 1920; *Nancy Ellen* (formerly *Pauline*), in 1927; *Linda*, in 1935; and *Haulboat* (formerly *Marian A.*), in 1936. A fleet of runboats in Atlantic's county harbor—*Muriel* (1935), *Bettie E.* (1939), *Harry B.* (1938), *Capt. Clayt* (1978), and *Miss Bettie* (1980)—belonged to the Clayton Fulcher Seafood Co. All but two of these old boats were still working when I first laid eyes on them, and all but two were built by Ambrose Fulcher of Atlantic, one of the most prolific of all Down East boatbuilders.

Fulcher is not very well known outside Atlantic, and even there he is a somewhat indistinct figure. He was born in 1865 and died in 1952. The censuses of 1900 and 1920 list him as a carpenter and, in 1920, as a merchant. In the genealogical history of the Fulcher family, *The Fulchers of Carteret County North Carolina*, Doily Earl Fulcher suggests that the term "mer-

chant" may refer to boatbuilder. But by that time, Ambrose certainly had been building boats for a long time and had a reputation as a master boatbuilder. He was commissioned to build *Aileen* in 1919, *Aleta* in 1923, *Braxton* in 1926, and *Pauline* in 1927. Most likely, he was building others at the same time.

Like other boatbuilders of his day, he used the simplest tools—hammer, saw, adze, and straight edge—to turn out 18-foot skiffs, 40-foot workboats, and even larger trawlers. He was a man of regular habits who in a long lifetime and with the help of his son-in-law and partner, Ervin Robinson, was responsible for an extraordinary number of boats. "Whether or not he has an order," a reporter from the *Beaufort News* wrote in 1942, "Mr. Fulcher keeps right on building. He told the reporter a few days ago that he built more than one thousand hulls at his yard within the past fifty years of his work there. Although eighty [actually seventy-seven] years of age, he is active as a hearty sixty-year-old man." And that was ten years before he died at eighty-seven. According to one source, he had just completed a boat the month in which he died.

Building a thousand boats doesn't seem clearly impossible, given his longevity. If true, the sheer number suggests an uncommon vigor and a stern self-discipline—someone who got up in the morning knowing what he would do that day and the next and the next one after that, and who didn't get bored or depressed about that prospect.

Many are the stories told about "Mr. Ambers," as he is almost unfailingly remembered. One of them is how in the early morning, before first light, he walked along the woodland paths of Atlantic to his waterfront boatyard carrying a lunch pail and a kerosene lantern. "They always said he would take a light of a morning and walk down the shell path along the shore," fisherman Buster Salter of Atlantic told me. "They'd see him a-goin' and he'd work all day buildin' them boats and that night he'd go back home after he worked all day on them boats."

James Paul Lewis of Davis knew Ambrose Fulcher well. Lewis's first wife was Fulcher's granddaughter, and Lewis lived with Mr. Ambrose in Atlantic before his death. Lewis was a pallbearer at his funeral. "[Fulcher] hung his coffin overhead in his boathouse," he said. "Everybody had seen it, discussed it. He lived for so many years after he built it that the cloth had deteriorated by the time he died and his wife had to get new cloth for it." A coffin hung in a boathouse wasn't all that uncommon, since boatbuilders were often called upon to handle some of the necessary carpentry in their communities. It made a good story, though.

Photos of Atlantic harbors from the 1950s are full of boats that bear Fulcher's signature style. They had tall cabins and were mostly employed in long-haul fishing operations. In a long-haul fishing operation, two workboats tow the ends of a long net for a couple of miles, then crisscross so that the net becomes a loop in which the fish are corralled. A boat dispatched by the fish house, called a "runboat" or, formerly, "buyboat," then bails the captured fish into its hold, ices them down, and returns to the fish house. Tradition-

Ambrose Fulcher, Atlantic, 1940s (courtesy of Alexis Jones)

When I was growing up [in the 1940s], I spent several summers with my Uncle Ambrose [Fulcher] and Aunt Becky [Ambrose's second wife] in the very small fishing village of Atlantic, North Carolina. . . . Ambrose was a boatbuilder, working alone in a small workshop. As a boy, I spent a number of summer days in and around his shop. He usually gave me something to do, probably to keep me out of his way. Since then, about sixty-five years later, nearly every time I have walked into a woodworking shop, I can recall the fragrance of his freshly sawn wood. I do recall that he would lay the keel of a boat as far as he could go with it inside his shop . . . then open the double back doors, stop by the local men's gossip group . . . and let them know when he would be ready to roll the boat out of the shop onto logs which he had prepared to hold the skeleton of the boat while she was being finished. When he got enough men, they would roll the finished boat into the water, the logs being quickly transferred from the bow to the stern as the boat traveled down the sandy slope.

At lunch . . . we could stop by the fish house and if a boat was there, someone would toss Uncle Ambrose a fish of his choice. That's the way folks were there. He would put it in a burlap sack, along with a piece of ice from the fish house to put in the ice box at home until the next day. Some days Ambrose would wade out in the water behind the shop and get a bucket of clams (he kept a supply) to take home. He would set the bucket outside the kitchen and cautioned everyone to be extra quiet so the clams would relax and he could shuck them easily.
—Alexis Jones, Galax, Virginia

ally, the workboats would leave the community on Sunday and return to Atlantic the following Friday.

One of the houses Ambrose Fulcher occupied during his lifetime was on Morris Street, just around the block from my apartment and not far from the harbor. Nearby, facing the sound, was his old boathouse, now a garage. After his first wife died, he married Rebekah Hardy, the daughter of Rev. Lemuel H. Hardy, pastor of the Hunting Quarters Primitive Baptist Church in Atlantic, and he moved to the house next to the old church. When I took walks in the evenings down the dirt paths toward the old Primitive Baptist church, I would think of Mr. Ambrose walking

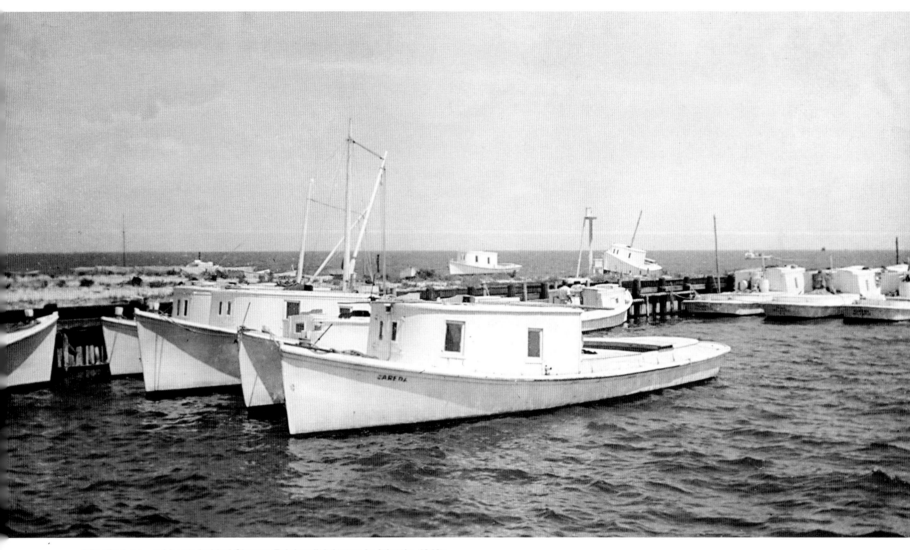

Atlantic-type workboats behind Clayton Fulcher fish house in Atlantic, 1940s
(courtesy of Alexis Jones)

there, lantern in hand. In the cemetery adjacent to the school, he is buried next to his first wife, Sarah James; their daughter, Olivia (dead at twenty years old); Ervin Robinson, Olivia's husband; Ervin's second wife, Bertie; and the tiny gravesites of the Robinsons' infants. Fulcher's gravestone is the tallest. At the top of the stone is a cartouche-like relief carving of a crossed saw and hammer. The epitaph reads

Ambrose M. Fulcher
Born
May 23, 1865
Died
Jan. 25, 1952

He trusted in God, loved truth,
practiced virture [sic], and left to the
world the priceless inheritance
of a good name.

Fisherman Danny Mason of Sea Level owns several Fulcher boats: *Old Salt*, *Haulboat*, and *Muriel*. *Old Salt* may be the oldest fishing vessel working in the sound today. It seems almost miraculous that the boat is still on the water. A boat's age, of course, can be misleading. A ninety-year-old workboat might be one of the youngest vessels on the water after some radical surgery and a few expensive facelifts. A workboat is "vintage" for only a little while, if ever. Salt air and punishing weather, hard use, and pounding in heavy seas are tribulations for wood. They conspire against a boat's longevity and good looks, which is why I see workboats with peeling paint, gouged hulls, and sprung boards. It's why fishermen abandon boats in a marsh. An old workboat still on the water is like an old house with a cable dish on its roof: It means that the owners have adapted to the modern world. A working Core Sounder is afloat on the strength of its ability to adapt.

Ambrose Fulcher built *Old Salt* with a cabin with rectangular side windows and small doors in front for the captain to see where he was going. Today, like most fishing boats, there's a pilothouse atop the cabin, a feature that began to appear in the 1940s or 1950s. The boat's hull was open, there was no deck, and its power came from a little sixteen-horsepower, two-cylinder Lathrop engine, often referred to humorously as a "putt-putt" engine for the sound that it made.

It takes Mason a full five minutes to account for some of what's been done to the boat just since 1965, when his stepfather bought it. First, a more economical and dependable diesel engine replaced the old V-8 Chrysler motor. After about twelve years, that engine had to be rebuilt, and in another twelve years another diesel engine was installed. In 1977, Mason brought *Old Salt* to South River, where the Edwards brothers added a new keel and sanded and renailed its planks. In the early 1980s, it went to Marshallberg for a new pilothouse with bigger windows. In 1990, at Harkers Island, Walter Chadwick and his son Jamie replaced all but one plank on each side. They put in a completely new round stern, decked it over, and added a waist to give the boat a little elevation. About

seven or eight years ago, the hull was fiberglassed at Marshallberg. A few years after that, the driveshaft broke and was replaced. In about 2004, Mason had the engine completely rebuilt and added two new fuel tanks.

"That's about all I know to tell you, except for some odds and ends," he said, "some new electronics and stuff like that." Adding "odds and ends" every couple of years means there's not much of the original *Old Salt* left.

An old boat testifies as much to a fisherman's bull-necked will to survive as to a builder's vision and skill. On a deeper level, it can be read as the physical equivalent of the imperative "Adapt or Die" that has shaped the lives of Core Sound inhabitants for two and a half centuries. Each boat represents adaptations to new materials, new tools, new technologies, and even new fisheries. An Atlantic workboat is a mutable, changeable document. Workboats are built, fished, repaired, and rebuilt. They are sold, rebuilt, and repaired again and again. Change is part of a boat's life history, and keeping an old boat afloat takes more than the cosmetic effects of a blinding morning sun. It takes the skills of a Marshallberg carpenter, a South River mechanic, and a Harkers Island fiberglass specialist. It takes a lot of Down East communities to keep a boat afloat.

You can read *Old Salt* like a book and learn a lot about its world. Its V-shaped ("deadrise") bottom and a freeboard that practically kissed the waterline before its waist was raised announce that this boat's natural habitat is the quieter sound waters. The narrow hull—39 feet long, 10 feet in the beam—discloses a sharpie ancestry, a design that increased the push of the early engines. "They didn't have a whole lot of power for pullin'," said Jonathan Robinson, "but they could sustain a course to Ocracoke just about as quick as they can do today, because of the hull design." Its stern is rounded, a feature that tells you that its fishermen handle nets.

There's another vestige of the sailing sharpies on *Old Salt*—the "tuck." Ambrose Fulcher and other Core Sound boatbuilders found it useful to keep this feature, the underwater part of the hull at the boat's aft end that rises to the stern. With a high tuck, a builder could position the boat's propeller higher up on the keel, reducing the draft of the vessel and enabling it to move more easily in shallow waters. *Old Salt* has a moderate tuck, while boats like *Linda, Haulboat,* and *Miss Bettie* (built in 1980) carry a more pronounced tuck that lifts the stern often above the waterline. Because these three vessels were built as runboats—they carried fish from the fishermen to the fish house—the high tuck meant that even with a heavy load of fish the boats could get in and out of shoal waters. They could "trim right up and make good time," says Bradley Styron of Cedar Island. "In the days when they were doing that, time was of the essence because they didn't have a lot of refrigeration and ice was limited. They needed to get the fish back as soon as possible."

Ambrose Fulcher built so many boats over his lifetime that he pretty much defined the look of an Atlantic-built workboat. Even today, seeing *Old Salt* on

You can tell an Atlantic boat by the sheer onto 'em, and they're straight-sided. They built the sides of them and put pins through 'em, and then they put the stem onto them and put a long stretcher in there and they bent them and pulled them in until they got the shape that they wanted. Then they put the ribs into her and the floor timbers into her. A lot of boats today, they frame 'em up first, but in Atlantic they made the sides first. They're dry boats, and they're shallow drafted. They got a lot of tuck into the stern onto them so they don't roll as much. And they got the round sterns onto them. They had 'em round-sterned because they worked better around nets.

—Buster Salter, Atlantic

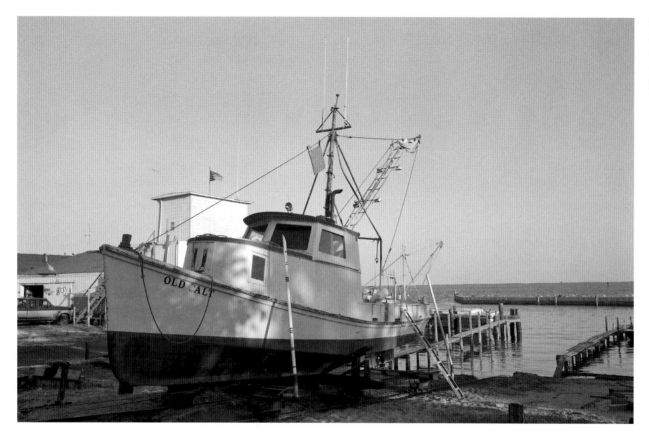

the water, many older fishermen instinctively recognize it as a Core Sounder, an Atlantic-style boat, and an Ambrose Fulcher–built workboat.

■ ■ ■ On display on Harkers Island, under a shed outside the Core Sound Waterfowl Museum and Heritage Center, another iconic Core Sound workboat, the *Jean Dale*, stirs memories among the old-timers who see a Core Sound sink netter, a Harkers Island–style boat, and a Brady Lewis–built workboat. A gen-

eration younger than Ambrose Fulcher, Brady Lewis (1904–92) was a legendary boatbuilder from Harkers Island. He built the 33-foot *Jean Dale* in 1946 for sink-net fisherman Harry Lewis, also of Harkers Island.

With its sweeping sheer and squat cabin, *Jean Dale* is celebrated as the most beautiful and graceful of all the Core Sounders. Its low-built cabin was a feature shared by boats built by Mildon Willis in nearby Marshallberg at about the same time, but it was quite different from the high cabins of Atlantic-

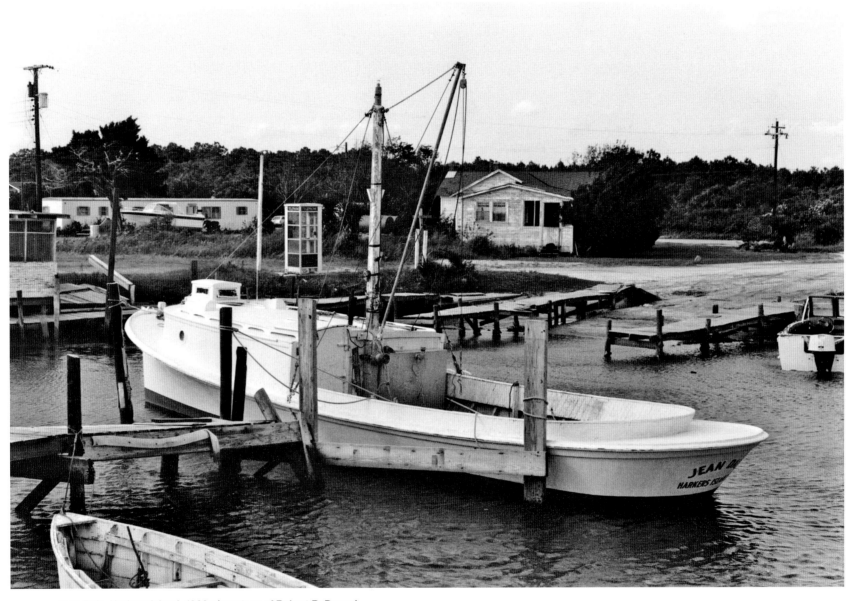

Jean Dale, Harkers Island, 1960s (courtesy of Robert B. Dance)

Jonathan Robinson, Atlantic, 2012

A great story I've always heard about the sink netters of Harkers Island, . . . they built boats light and fast with little houses [cabins] on them. Some of the fellows from Atlantic . . . used to go to Cape Lookout sink netting . . . on an Ambrose Fulcher–built boat. One of the boys from Harkers Island was on one of those sink-net boats with the little houses and he said, if he ever built a boat, he was going to build a boat like Ambrose Fulcher where you could stand up in the cabin. He said, "There I was bent over in the cabin, trying to get my pants up. I had my nose shut of my brother's ass trying to pull my pants up, and I looked out the port light and somebody went by on a Ambrose Fulcher boat, and was standin' up there to the mirror shavin'."
—Jonathan Robinson, Atlantic

hauling. Given their boats' limited engine power and the long distances the fishermen often traveled, spending a week on the water made economic as well as practical sense. Thus, boatbuilders made tall, roomy cabins that provided more headroom for close-quarters living. On the other hand, Harkers Island and Marshallberg fishermen were located in the western part of Core Sound, where they had better access to the ocean than Atlantic's fishermen. Many western fishermen tended to be sink netters who fished in the ocean and around the inlets and might return home at the end of the day. Sink netters strung about 500 yards of weighted net overboard, and the fish would gill themselves in the net's mesh. After every set—sink netters might set nets several times a day—the fishermen would pull in the net, clear the

built boats. It's difficult to say exactly why the two cabin styles evolved, although they may well have been influenced by the different kinds of fishing that the two communities did, which, in turn, may have been based at least partly on the communities' locations in Core Sound.

In the far eastern precincts of the sound, for example, Atlantic fishermen tended to do a lot of long-

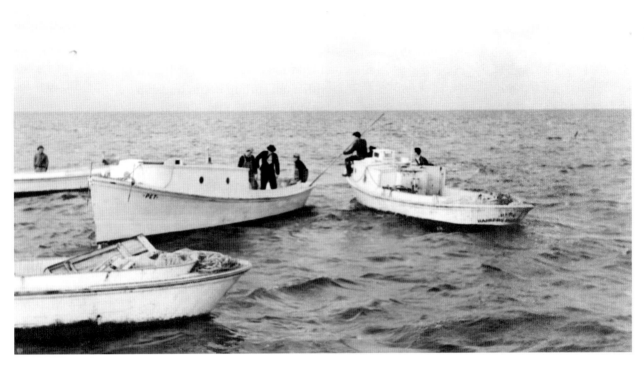

fish out of the net into their boats one at a time, and then come in to unload the fish at the fish house. With this kind of fishery, a high cabin had no benefit and might actually hinder operations, making the boat top-heavy and unstable in rough ocean water.

Yet, Harkers Island boats were also used in long-hauling operations up around Ocracoke, which meant that their fishermen spent at least several nights away from home in their cramped quarters. For this reason, there's no doubt that an overriding concern among Harkers Island boatbuilders was style. They were more willing to sacrifice a little comfort to make their boats look good. Arguments about which community's boats are prettier still take place Down East. "The boats they built down there, they were good boats, but there weren't no shape to them, you know what I mean?" said Clem Willis, a Harkers Island boatbuilder. Some Atlantic natives actually agree with the comparison but shrug it off. "The Atlanticers, we weren't really concerned about how pretty a boat was," explained Jimmy Amspacher, an Atlantic native who rebuilt *Jean Dale*. "We were more concerned about how it worked. Our boats were built to work, not to be pretty."

Bow design also distinguished Harkers Island/ Marshallberg boats from Atlantic boats. *Jean Dale*'s

James Paul Lewis, Davis, 2012

The *Miss Lue* was the first boat we built. We started the *Miss Lue* in '69, and it took two years to build the boat. My mother was Miss Lue. She was still picking crabs until 1998, when she was eighty-eight years old. She was ninety-three when she died in 2004. She said if she had picked crabs longer she'd have lived longer.
—James Paul Lewis, Davis

■ ■ ■ Fishermen say they are superstitious about changing the name of a boat. James Paul Lewis told me a story of a man named Jim Allison Salter whose boat was named *Red Wing*. He wondered why a man would give a boat a name like that and found out that Salter had gotten confused when he was filling out the boat papers. In the line for "boat name" he filled in the name of his boat's engine: "Red Wing." Yet he never changed the name because he was afraid it would bring bad luck.

It must be a very old superstition honored more in the breach than in the main, because captains changed the names of their boats all the time. *Capt. Daily* of Sea Level was once called *Lavonne, Nancy Ellen* was *Pauline, Old Salt* was *Aileen*, and *Haulboat* was *Marian A.* A boat often took on a new name when a fisherman bought it from another waterman. With a long history, a boat might trail a litany of names on its documentation papers. *Luther Lewis*, built in Davis, became *Kristy L, Capt. Alton, Capt. Buster II, Miss Winmar*, and *Basil B.* at various times. Its sister ship began its life as *Miss Lue* and then, when it was sold and left the area in the 1990s, became *Miss Theresa* and *Miss Helen*, only to have become *Miss Lue* again when I saw it at a dock in Georgetown, South Carolina, in 2012.

Yet sometimes an old name persists, as if people could not get used to the new name or preferred the old one. Danny Mason said that when he bought *Aileen*, he thought for a long time about what to name the boat and then finally chose *Old Salt* because his uncle used it as his CB radio handle. "We still refer to

her as ol' *Aileen*," he said. "When we talk to people, we say, 'There's *Aileen*!'"

I showed a photograph of *Haulboat* to some Cedar Island fishermen one day, and they all said, "That's the *Marian A.*!"

■ ■ ■ Individual workboats seem like floating memory banks, living histories. Looking at a boat's photograph, many fishermen I interviewed, and some family members as well, acknowledged familiarity with the vessel, even if it were from another community, and some could rattle off details about the builder and owners. Others knew the family connections of the person whose name was on the boat. They might even tell me when a boat was sold, who bought it, and its new name.

Some reminiscences possessed an extraordinary density of names, places, and events. Keith Mason of Stacy stunned me one day in 2006 with his intimate recall of facts about two boats docked in Sea Level. "That's *Hilda P.*, Tom Salter's boat," he said of one.

His grandson, Mortie Adams, owns the boat now. They don't work her much anymore. Mortie's got a job over on the Banks working for the Park Service since Hurricane Isabel. And that other boat, Leroy Goodwin over to Cedar Island owned the boat at one time. The name of her was *Four Kids* when Leroy had her, and when my brother bought her he only had one kid so he took the "F" off and named her *Our Kid*. She's up here to Styron's Creek now. Anyhow, he bought her from Leroy Goodwin,

and he owned her eight or ten years, I guess, and he sold her to Specklehead, Wayne Gaskill, and he still owns her. But she's been rebuilt a couple of times. He had her tied up at Styron's Creek in the late 1990s, and one of those hurricanes, Fran maybe, turned her over in the creek, tore the rigging out of her, busted the side of her. Nick Smith to Marshallberg rebuilt her for him, fiberglassed the outside of her.

The older a boat, the wider its network of connections. In the aggregate, these layers of detailed information sometimes enabled me to assemble a boat's "family tree," a genealogical web of connections and memories with the boat at the center. Indeed, a workboat plays another role in the community besides the practical purpose for which it was built. The stories and memories associated with a boat are like family tales told around the dinner table and passed down from one generation to another. They are as important to community life as family stories are to family life. Stories exist at large in these communities, and in a sense they draw people together. Workboats link people, families, and communities.

Down East people are so knowledgeable about the workboats in their midst because they have grown up around them, listening to the stories that their fathers and grandfathers told. Their small communities once might have been isolated from one another, but on the water, watermen have always been natives of the same wide and yet intimate metropolis. They recognize each other by the pattern of their boats' lights,

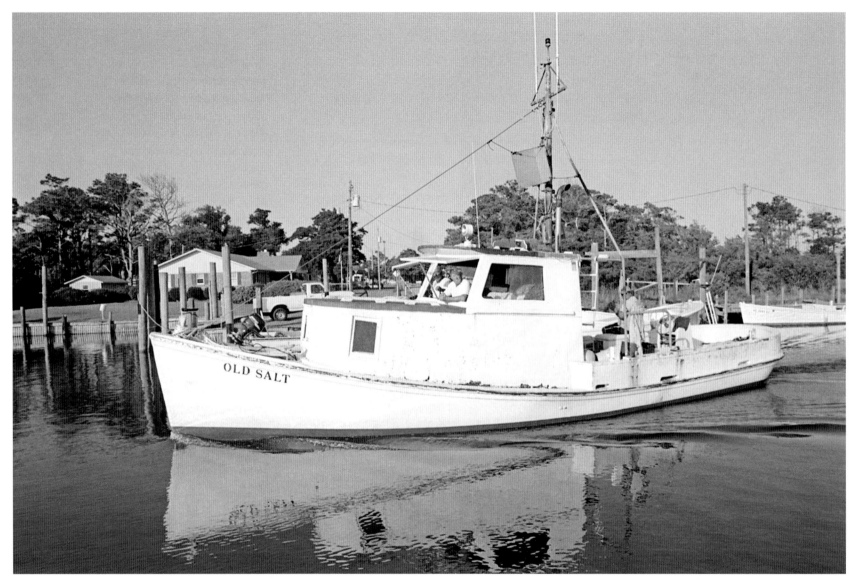

Plate 33. *Old Salt* coming in, Atlantic, 2006

When I started I bought Charles Smith's haul net boats. Two of them. One of them was named the *Nancy Ellen* which was built in 1927, and the other one was named the *Wasted Wood* which was built in 1932 by Will Mason. The *Nancy Ellen* was built by Ambrose Fulcher. Today I have another boat—I've done away with the others. I sold the *Nancy Ellen* and we junked the *Wasted Wood*. Today I have a Harkers Island–built boat that was built by Clarence Willis and the name of it is the *Miss June* after my mother.
—Buster Salter, Atlantic (interviewed by Susan Mason)

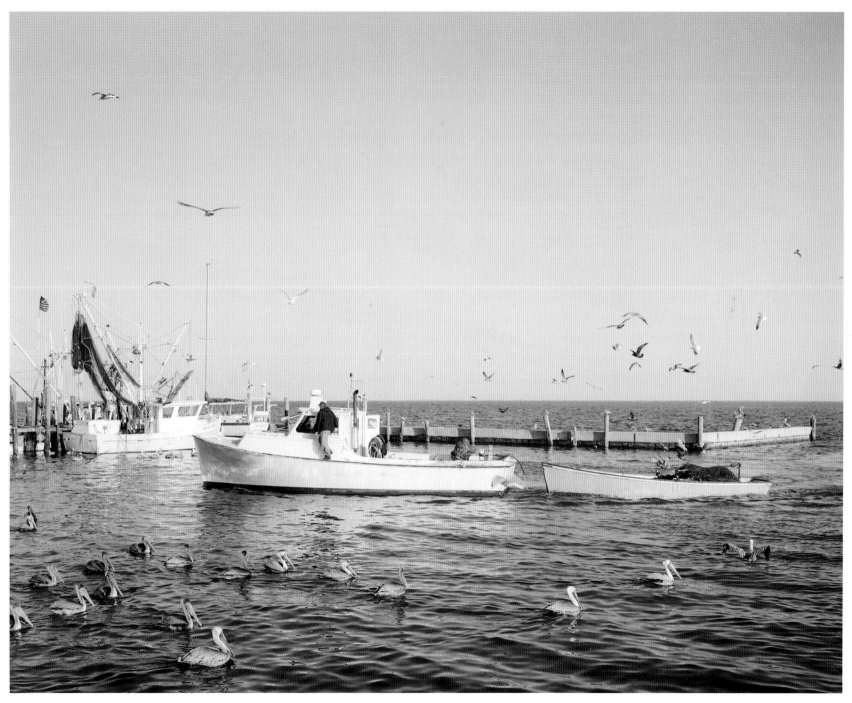

Plate 34. *Miss June* coming in, Atlantic, 2005

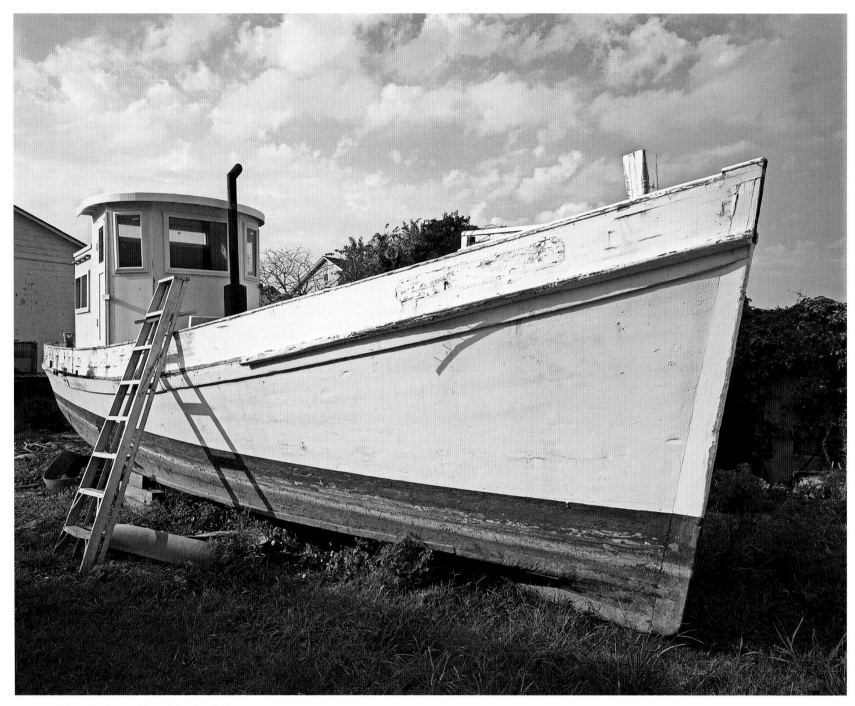

Plate 35. *Nancy Ellen*, Atlantic, 2006

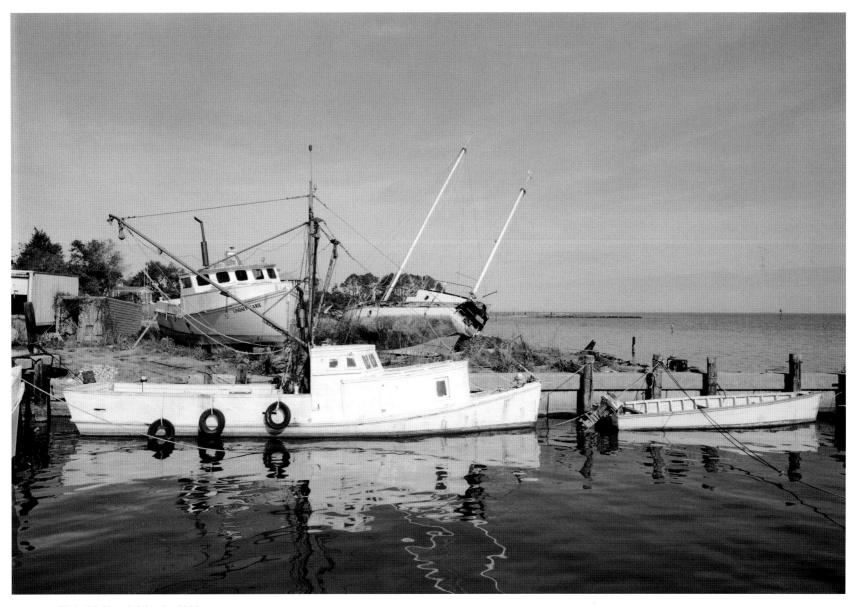

Plate 36. *Hazel*, Atlantic, 2006

I weren't very old when they built *Hazel* because I were born in 1915. My grandfather and father built her, and my father worked her for years a-long-haulin'. And after he got out of the long-haulin' he got another job and he sold her to John Lupton at Sea Level, and he used her for haulin' and shrimpin' for years. Then he took her over to his son-in-law, Leonard Goodwin, and far as I know, Leonard owns her now.

—Marvin Robinson, Atlantic

Plate 37. *Down East*, Atlantic, 2006

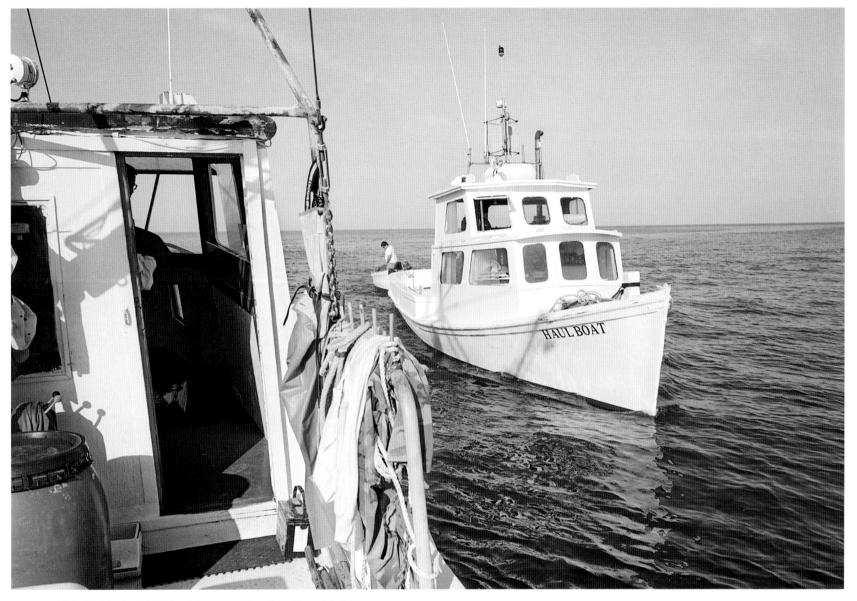

Plate 38. *Haulboat* (*Marian A.*) approaching, Core Sound, 2006

That's the *Marian A.* And that boat my grandfather had built, Ambrose Fulcher built it. Ambrose was my great-uncle. The *Marian A.* was named for Marian Agnes. That was my grandfather's first child, and she died. And of course, when you hear us say it, it's *Marin A.* Most of the time when a bunch of us get talking people can't understand us, and I try to talk slower and more distinctly so you can understand me. Most of us say, *Marin A.*
—Clay Fulcher, Atlantic

Plate 39. *Linda*, Atlantic, 2007

That was John Weston Smith's boat. Look at the decking onto it—this was used as a runboat. A runboat was used to go to haul crews and pick up their fish and bring 'em in to the fish house. At first they called 'em "buy" boats. They were goin' out and buying the fish and bringin' 'em back in to be weighed, sorted, and everything at the house. Used to, they had big old pan scales right on the boat. They bought 'em right there on the spot. And then they got to where they weren't doin' that and they got to callin' 'em runboats, because they were runnin' out to the haul crew, bailin' the fish in, and running back to shore.
—Clay Fulcher, Atlantic

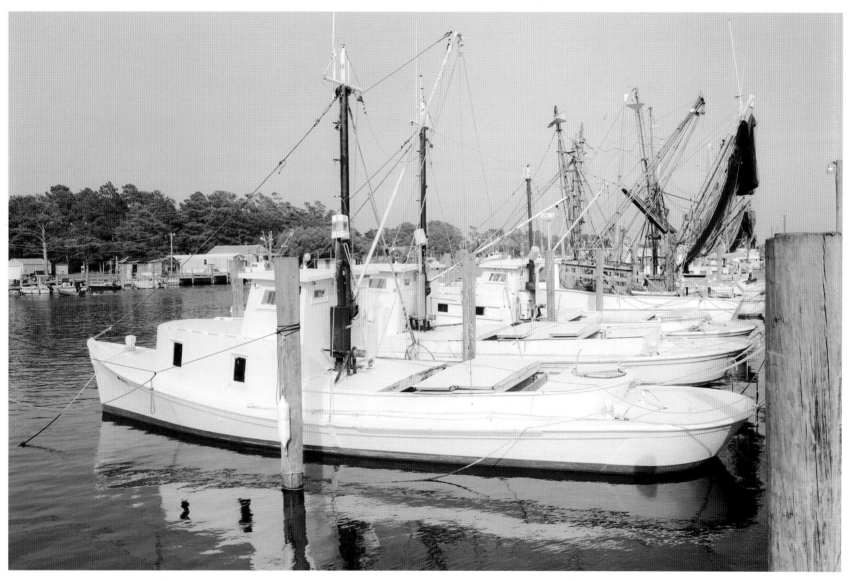

Plate 40. Clayton Fulcher Seafood Co. runboats, *Muriel* (front),
Bettie E., and *Harry B.*, Atlantic, 2005

The *Muriel* was built by Ambrose Fulcher for John Day. She was named after John Day's daughter.
The boat's seventy-something, I think. She's still living, Muriel is, and she's still going strong. Amazing!
Ambrose built them boats to have two cylinder engines in 'em, you know, pop-pop-pop type engines.
And then they put diesels in 'em and they've been running diesels for forty years. It's unbelievable how
they could be built like that. The *Bettie E.* used to run to Hatteras. It'd run every day to Hatteras.
—Clay Fulcher, Atlantic

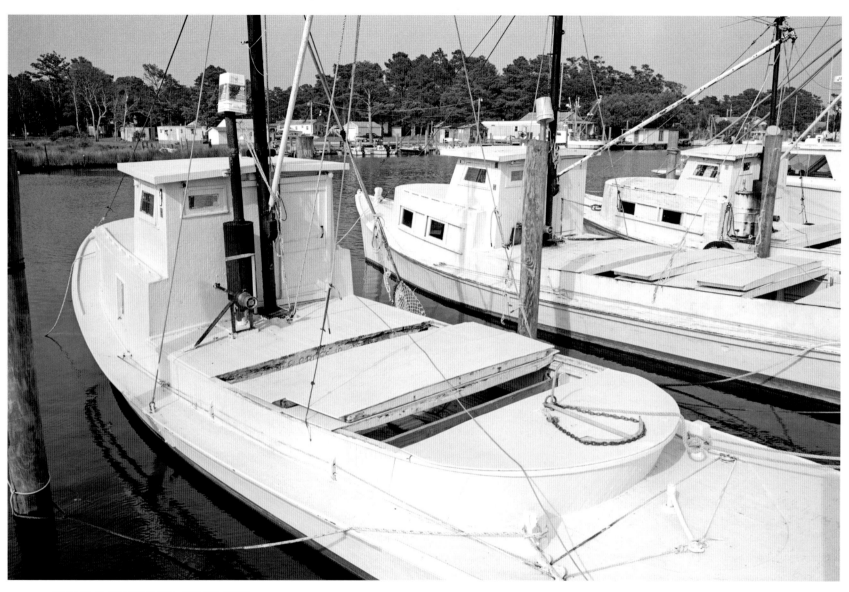

Plate 41. Fulcher runboats, Atlantic, 2005

Now in the mid-seventies, the *Bettie E.* was to the Straits marine railway sunk. She stayed there for a long time, and the haulin' started getting better and the Fulchers took her to Harkers Island and a fellow to Harkers Island named Dan Yeomans, I believe, he rebuilt her. I put fish probably in every boat in Core Sound long-hauling, and to me she was probably the best. She wouldn't carry as much as some of them, but she was the best working boat was ever in Core Sound, as far as loading. If you iced her right and stowed her forward, she'd carry 300 boxes of fish onto her, and she'd make real good time. She heeled over good when you were loading her. She was probably the best all-around runboat in Core Sound. She would carry about 30,000 pounds of fish. Some of them would carry 60,000 pounds, and others would only carry 15,000 pounds, but overall she was the best.
—Bradley Styron, Cedar Island

Plate 42. Runboat *Bettie E.* at Clayton Fulcher fish house, Atlantic, 2007

Plate 43. Rounded stern on *Harry B.*, Atlantic, 2006

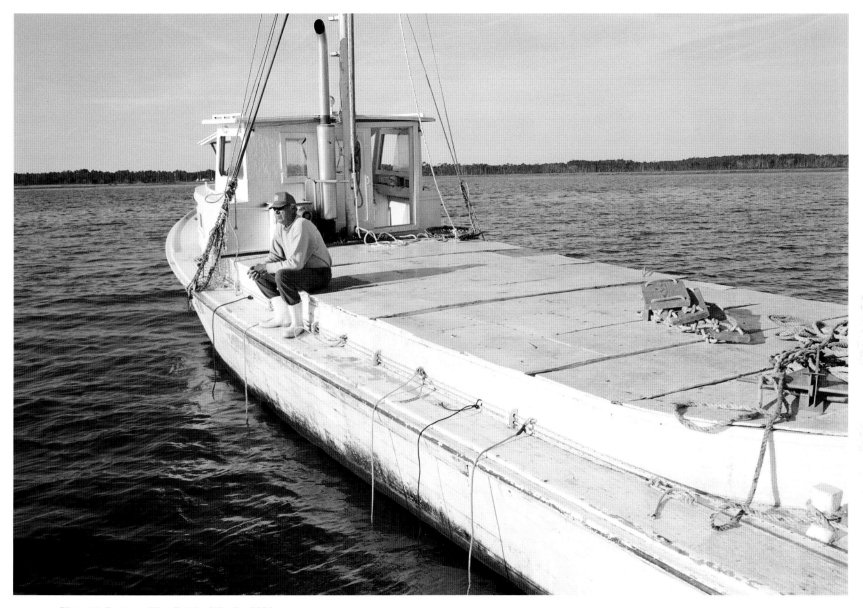

Plate 44. Runboat *Miss Bettie*, Atlantic, 2006

James Gillikin built *Miss Bettie* in 1980. The fishing was good. Believe it or not, at that time the Fulchers (Clayton Fulcher Seafood Co.) had the *Muriel*, they had the *Bettie E.*, they had the *Harry B.*, they had the *Capt. Clayt*, and they had the *Marian A.* as runboats. We were going farther after the fish, all the way to the Pamlico River, and you needed a boat that could carry the weight. Plus she was a good sea boat with the weight on her. Notice the lines on *Miss Bettie*, how much deeper this boat is than the *Bettie E*. That comes with a disadvantage. She's a lot harder to load—she didn't work as good as the *Bettie E.* But if you were at the Pamlico River and it was about a 6½-hour run back to Atlantic and you had to cross the Neuse River part of Pamlico Sound, you needed that extra freeboard. And that's the reason she was built.
—Bradley Styron, Cedar Island

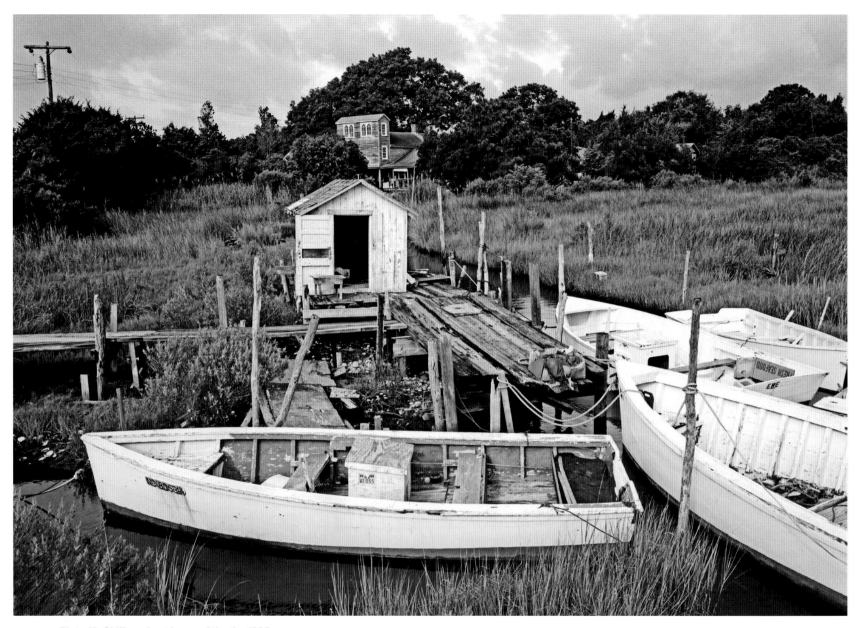

Plate 49. Skiffs and net house, Atlantic, 1992

That's old-timey mulleting [skiffs] there. Honey, mulleting is a spiritual experience. I love to go mulleting.
I loved it when I was a child. That was back in the day. I don't know whether people still do that. It's like
summertime mulleting, you know. You see them on flips, that's what we called it. Jumping mullet jump
out of the water. And we called it "flipping," they flip out of the water. That's what they call setting the
net on the flips. But honey, there's nothin' finer than to go mulleting. Oh, my lord! I love to do that.
—Pam Morris, Smyrna

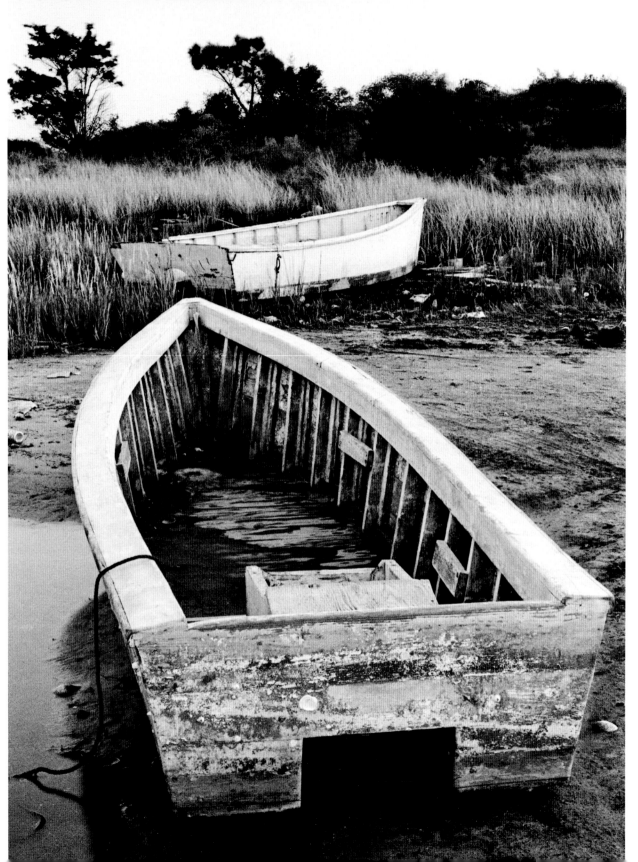

Plate 50. Two skiffs, Atlantic, 1985

See the design? They are all mostly straight-sided. When we build a 16- or 17-foot boat that's what we call a skiff. We put flare on 'em most times. When they build a 22-foot boat, they still call her a skiff. They used to come down here and look at one of our boats and say, "That's a nice lookin' skiff you got there." We'd say, "Skiff? Ain't no skiff, it's a boat."

—Pauly Lewis, Harkers Island

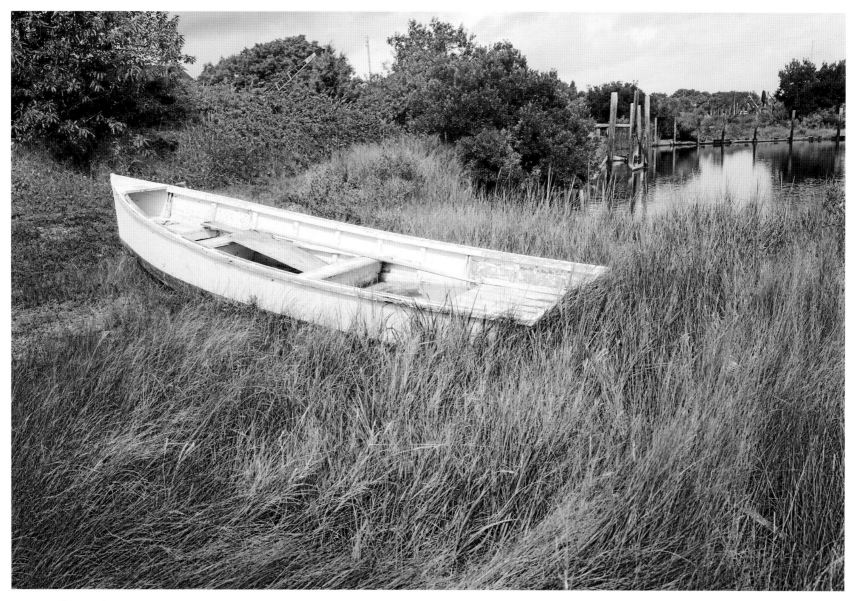

Plate 51. Skiff in marsh, Atlantic, 1992

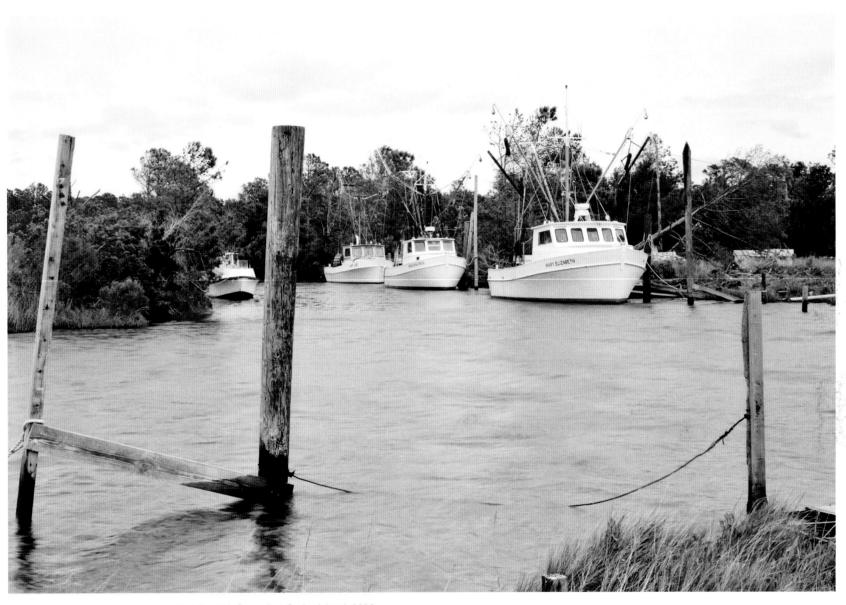

Plate 52. *Mary Elizabeth, Miss Rachel, Capt. Joe*, Cedar Island, 2006

The first boat, *Mary Elizabeth*, was built by Cecil Tuten of Williston. That's primarily a Harkers Island design. The second boat was built by a gentleman named James Goodwin, and that's probably a partial Harkers Island design and a regular Core Sound boat. The one in the back was built by Julian Guthrie. Julian Guthrie was a master boatbuilder. He built boats like this right on up into the 80-foot class. And he always had a reputation for building a nice strong boat.
—Bradley Styron, Cedar Island

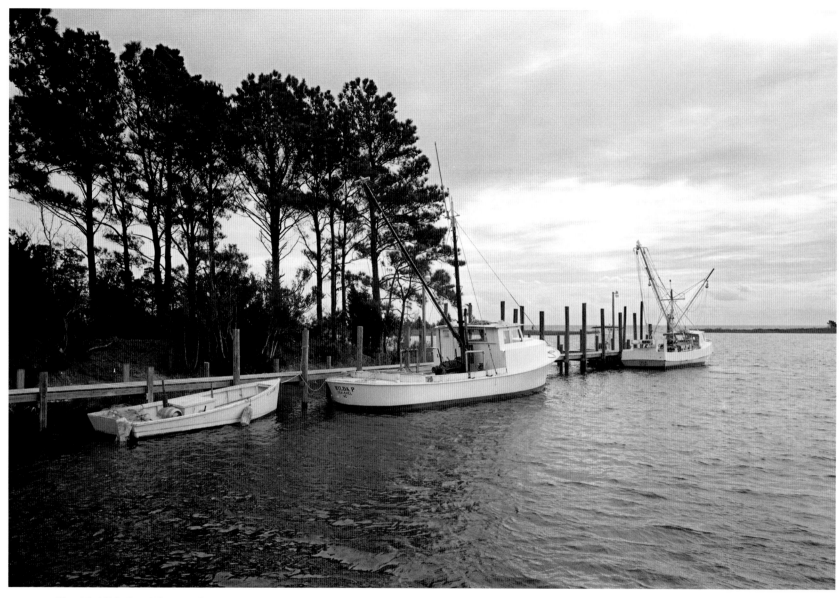

Plate 53. *Hilda P.* and *Our Kid*, Sea Level, 2005

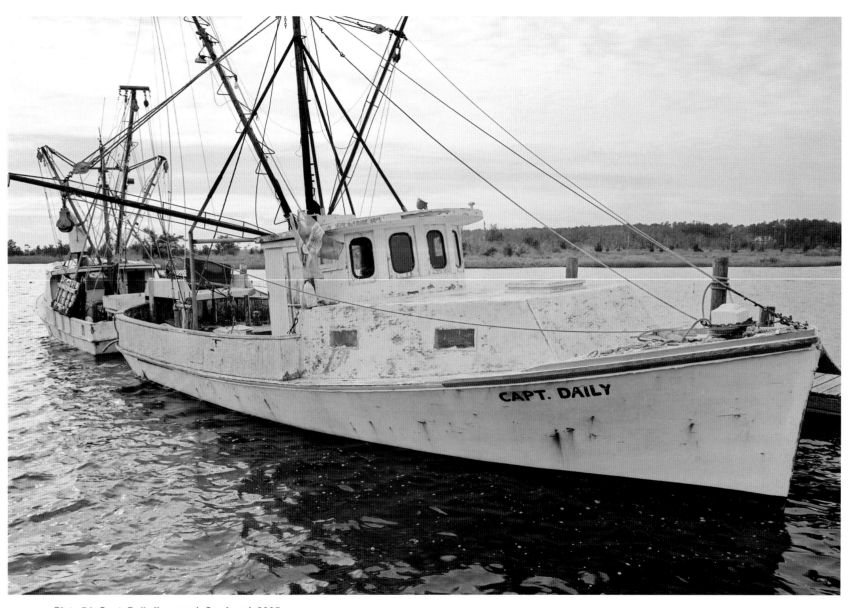

Plate 54. *Capt. Daily* (*Lavonne*), Sea Level, 2005

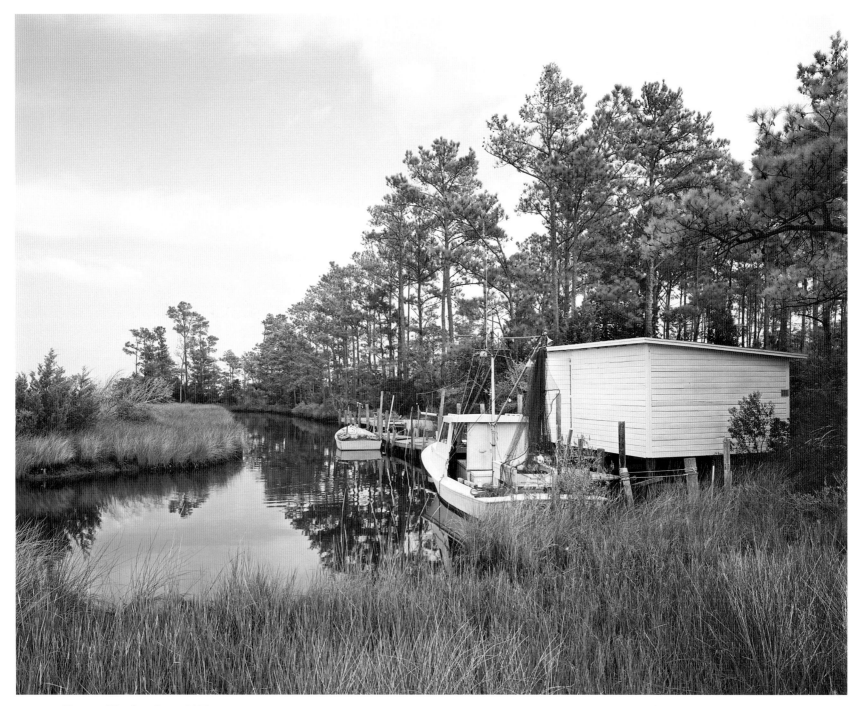

Plate 55. *Miss Sue*, Stacy, 2007

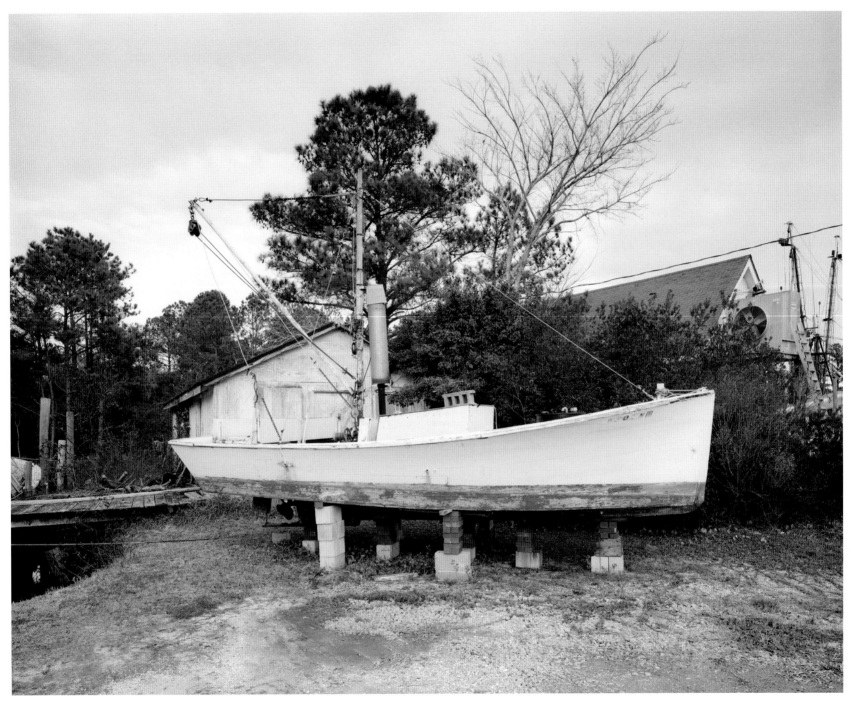

Plate 56. Workboat, Davis Harbor, 2007

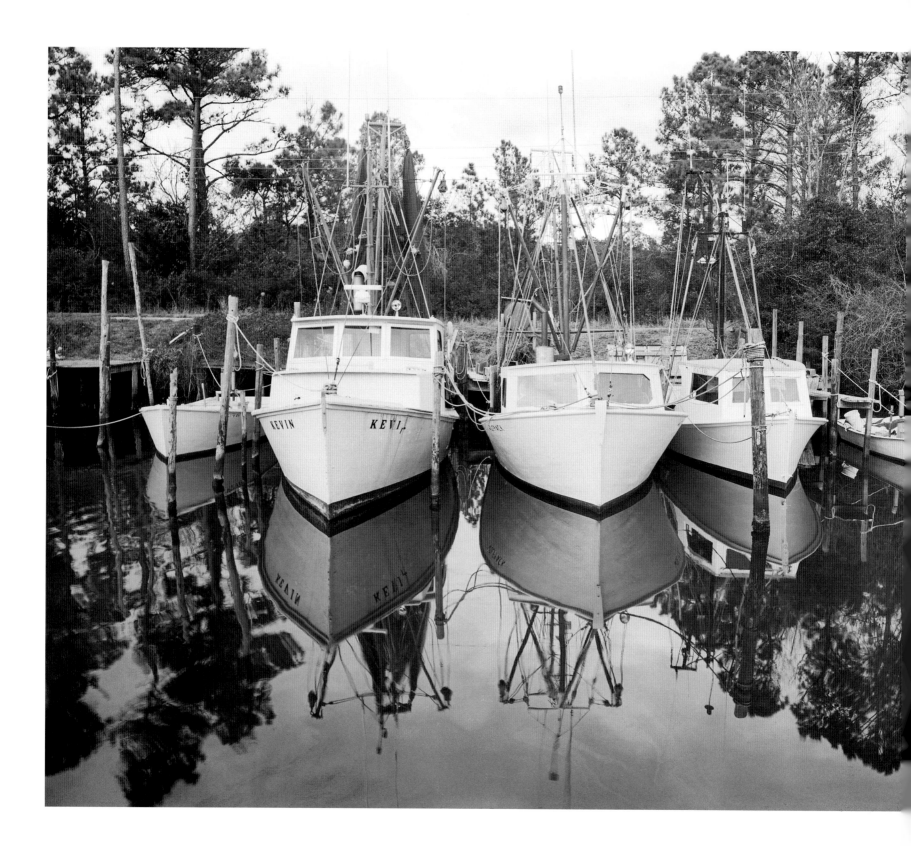

Plate 58. Abandoned skiff,
Harkers Island, 1995

Plate 57. *Kevin* and workboats, Davis Harbor, 2007

89

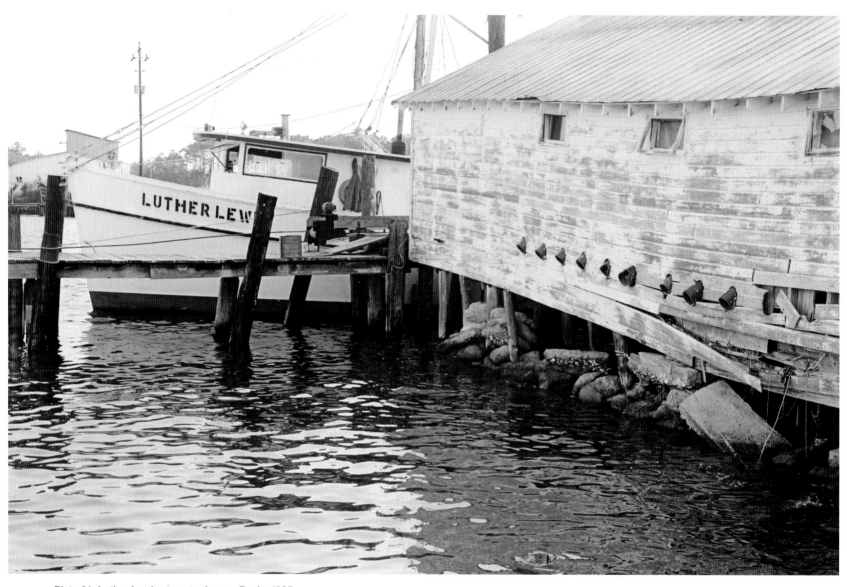

Plate 61. *Luther Lewis* **at oyster house, Davis, 1985**

The oysters played out in my lifetime and we started shrimping. Shrimping on the East Coast started here in Davis. We shrimped with *Ethel* and different boats that we had, and you couldn't sell the shrimp. No one ate them. There was one restaurant in Beaufort that sold shrimp, and if you ate shrimp the waitresses wouldn't serve you pie. Eat dessert after eating shrimp and it would kill you. They said the same thing about oysters. You drink milk and eat oysters and it would kill you. The oysters played out in the fifties. We thought it was hurricanes but it was pollution killed the oysters.
—James Paul Lewis, Davis

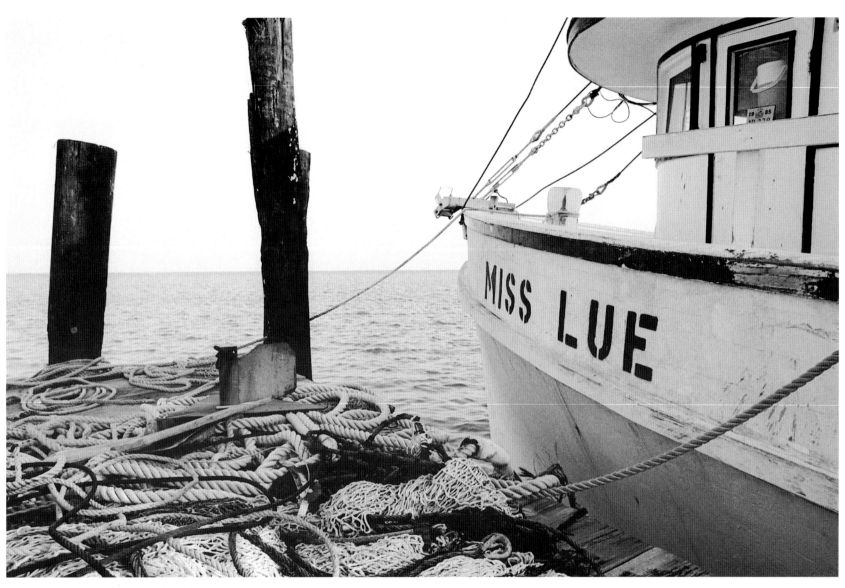

Plate 62. *Miss Lue*, Davis, 1985

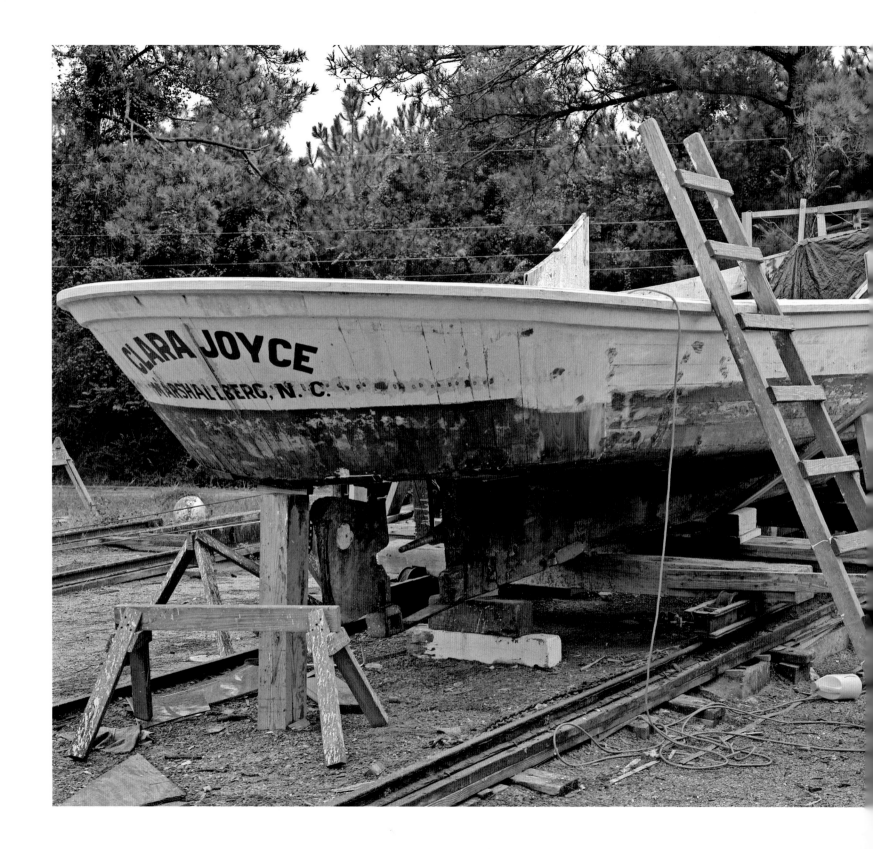

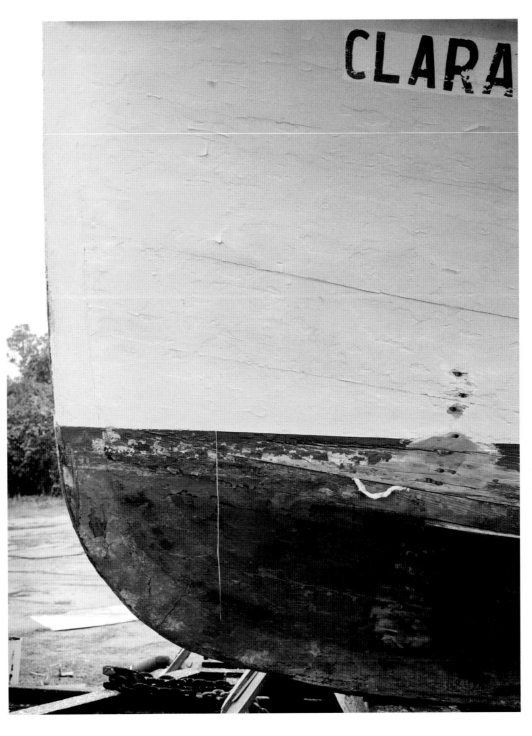

Plate 64. *Clara Joyce* (detail), Straits, 2007

Plate 63. *Clara Joyce* on rails, Straits, 2007

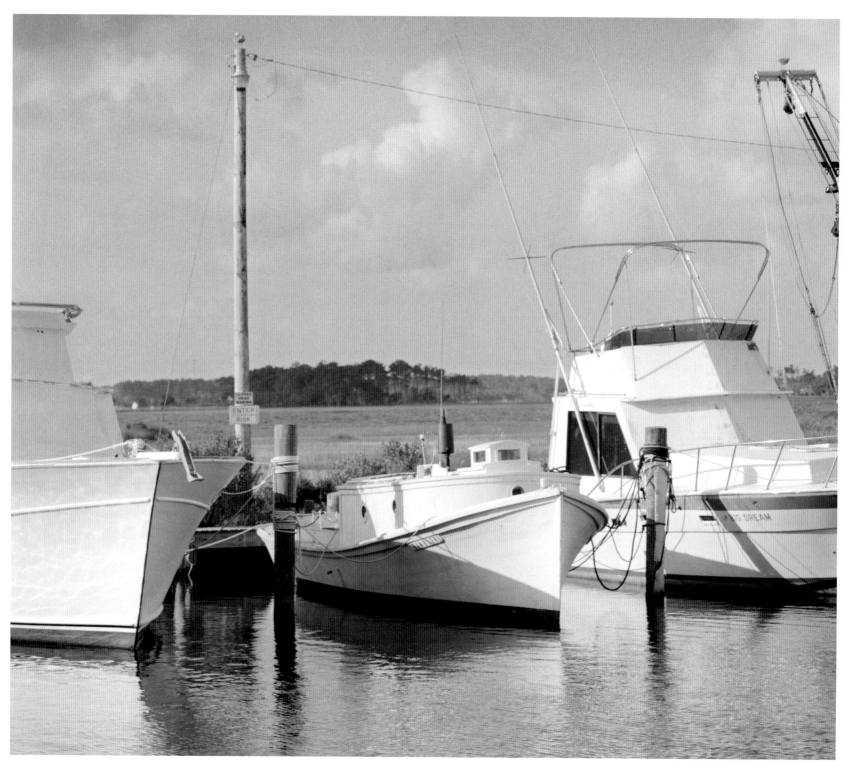

Plate 65. *Rambler*, Harkers Island, 2006

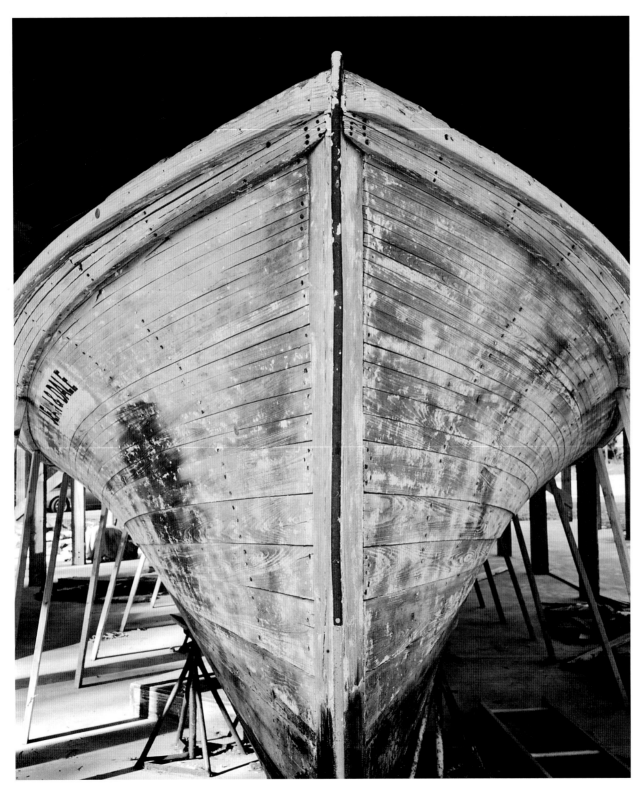

Plate 66. *Jean Dale*,
Harkers Island, 2007

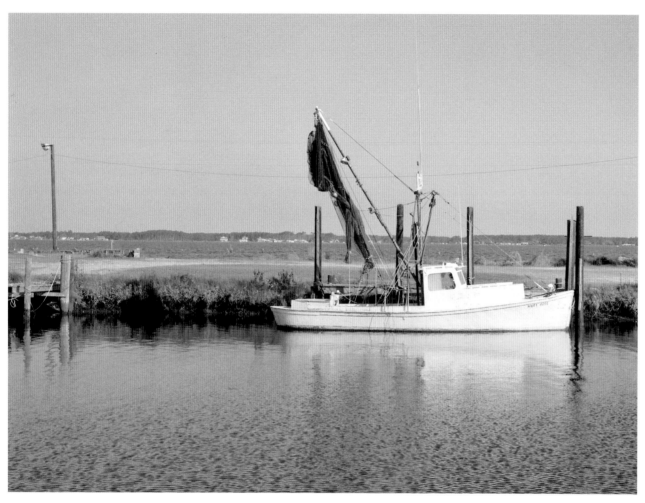

Plate 67. *Mary Rose*, Harkers Island, 2005

Plate 68. Shrimpboat, Marshallberg, 1985

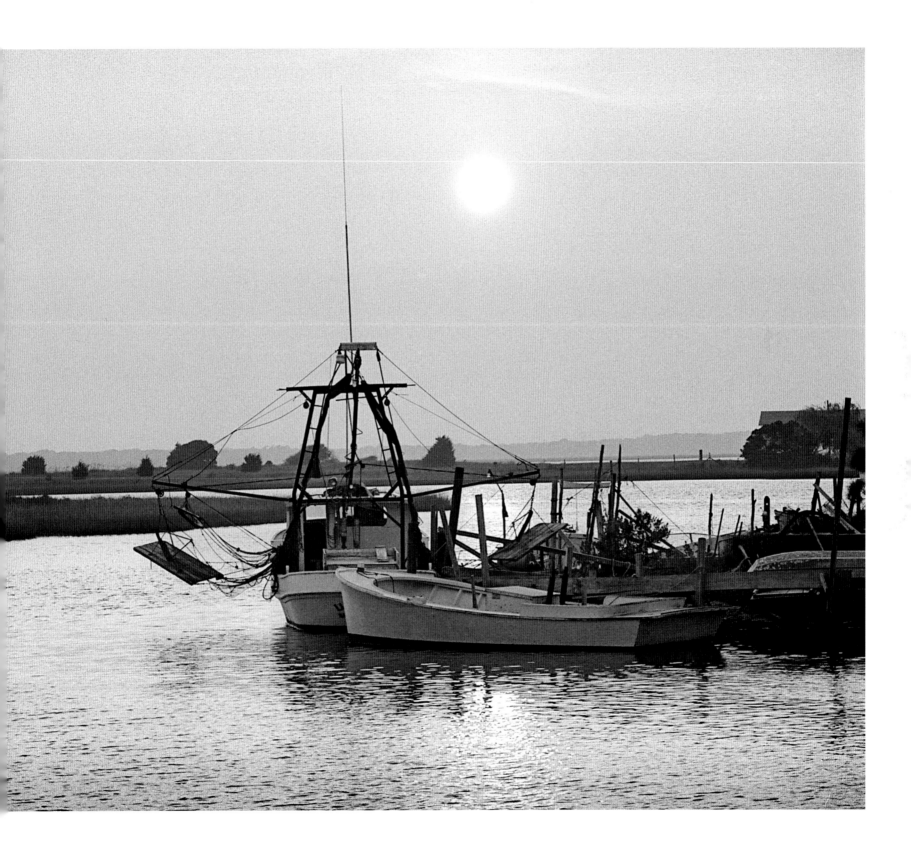

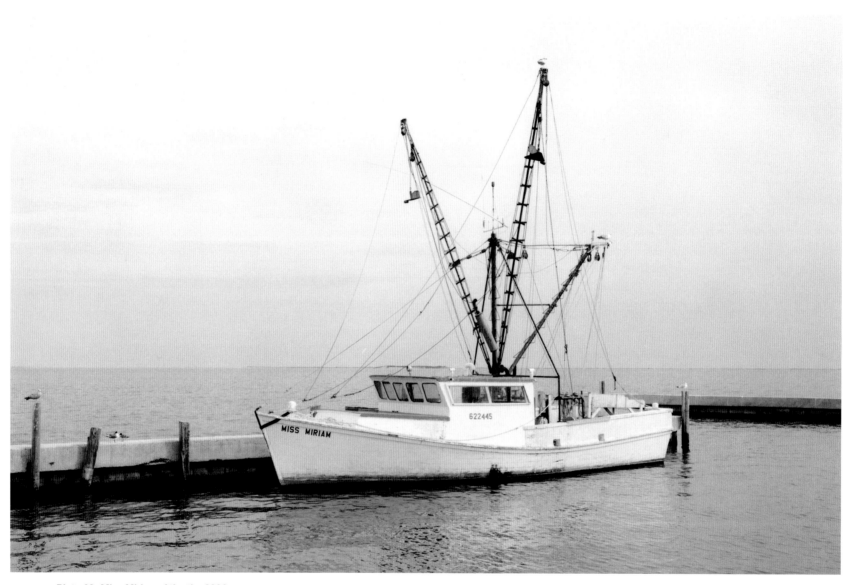

Plate 69. *Miss Miriam*, Atlantic, 2006

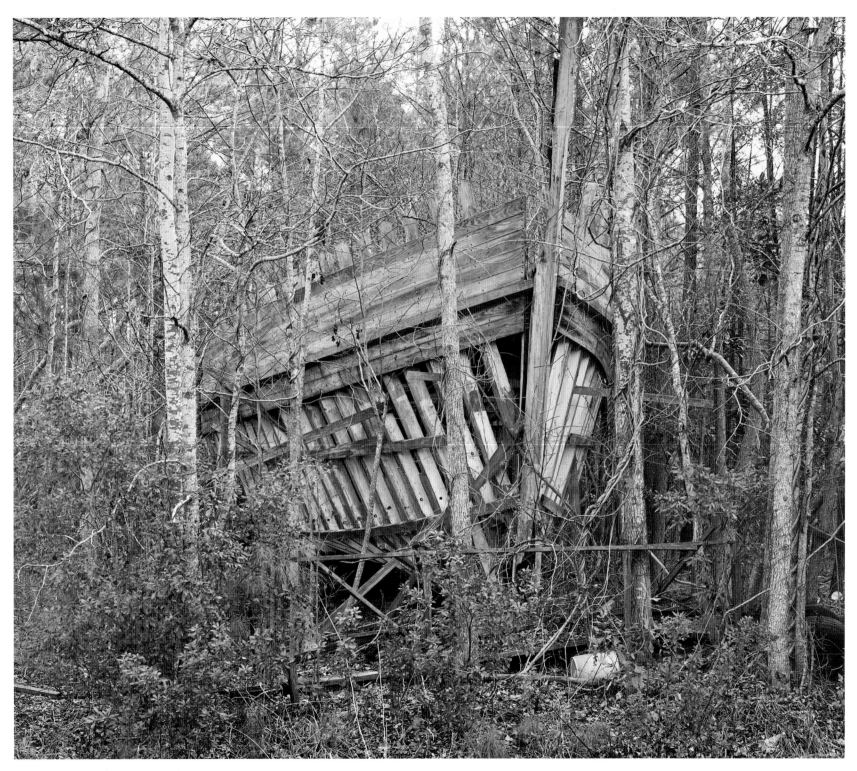

Plate 70. South River, 2007

The Fishing They Do

So many of the older boats that I photographed in Atlantic were built for long-hauling that I became curious about the fishery itself. Two fishermen, Buster Salter of Atlantic and Danny Mason of Sea Level, captained two of the last full-time long-haul crews working in the sound, and I pestered them often for information about how long-haulers worked. At their invitations, I accompanied them separately a half-dozen times over a couple of years and photographed this labor-intensive fishery. Long-hauling was hard to understand, and maybe even harder to explain, as Buster and Danny found out when they tried. It took me a long time before I could figure out what was going on during a long-haul operation.

Long-hauling, or long-haul seining, was once the major way that finfish were caught in Core and Pamlico sounds. One report claims it was started in Core Sound in the nineteenth century by fishermen on sailing vessels, although it's difficult to believe sailboats ever could have hauled long and heavy cotton nets. It was certainly a popular way to fish by the early twentieth century, when engine power replaced sails, and at one point more than a dozen crews from Down East communities long-hauled in the sounds at the same time.

Long-haulers catch fish in nets, about as basic a description of the process as one can get. Two haul-boats, about 30 to 40 feet long, each with a crew of three and towing a smaller skiff, pull the opposite ends of about 1,350 yards of net attached to a 100-yard tow cable for a distance of 1 to 3 miles. The net actually comprises eight different nets that are connected to one another by wooden staffs. The two "back nets"—the farthest from the boats—have the smallest mesh and are attached to two "third nets," which have a larger mesh. The third nets are attached to four "wing nets," two on either side, that are the closest to the boats. The "cork line," composed of small cork buoys spaced at regular intervals along the top of these nets, and the "lead line," made up of small lead weights on the net bottoms, keep the nets hanging vertically close to the sound bottom. The nets are like a moving fence that slowly herds the fish in the direction in which the boats are moving. The boats pull the nets from a deeper area of the sound to a shoal or a shoreline with a "footing bottom"—

My mother once told me the life of a fisherman is hard. They age beyond their years due to the sun, wind, and hours at sea. She said: "Just before you think you are going to starve you will make money, and just before you think you will get rich you'll go back to thinking you will starve."
—Mildred Gilgo, Atlantic

water about chest-deep. It can take anywhere from a few hours to seven or eight hours or longer, depending on the seasonal presence in the water of slimy, grasslike strands that fishermen call "animal grass" (a bryozoan, *Zoobrotryon verticillatum*), which can slow the process practically to a standstill.

When the boats reach shallow water, the crew plants an 8-foot-long "footing stake" into the bottom. In an elaborate and somewhat confusing choreography, boats tow each set of nets past the footing stake, and men in skiffs move back and forth pulling nets into the skiffs and creating a gradually shrinking circle of net. In the last stage of the operation, a new net, called the "bunt net," comes into play. Fishermen attach one end of this net to the footing stake and the other end to the leading end of a back net that is pulled past the stake. The bunt net now holds all the fish.

As the loop of net gets smaller, the trapped fish churn about, and brown pelicans and other seabirds come out of nowhere to dive into the roiling water. The runboat dispatched by the fish house has been standing by during the latter stages of the operation. It now draws near so the crew can attach the staff end of the bunt net to this vessel. The rest of the crew climb into a skiff and pull the bunt net tight so that the fish can be bailed into the runboat's hold. With a small haul of fish, the bunt net may be no more than 10 or 15 feet in diameter and the bailing operation may take less than an hour. In times past, a haul was sometimes so large that multiple runboats would take many days to bail all the fish.

After the fish are loaded and iced down, the runboat leaves for the fish house, where the fish are sorted, packed, and shipped to market. The haulboat crews spend time removing the little fish that have wedged themselves into the mesh of the back nets. They take in these nets, folding them into the skiffs, and then they head home. Not so long ago, they might have made another haul, or if the hour were late, they would cook supper and sleep until the early hours of the next morning. In recent years, crews generally prefer to return home after each haul.

■ ■ ■ At 5:00 A.M. one October at Atlantic Harbor, I climbed aboard Danny Mason's boat *Miss Olivia* for one of the last long-haul trips of the season. Built in 1982, *Miss Olivia* is a youthful boat, compared to the two old workboats, *Old Salt* and *Haulboat*, that Mason uses for long-hauling. Mostly he shrimps and dredges oysters in *Miss Olivia*, but when *Old Salt* came up limping this week, the newer boat had to be pressed into service. Danny Mason didn't want to lose a day having the older boat repaired, not at the money end of the long-haul season. It was a late start—other mornings we had left at 3:30 A.M. The night before, Mason and his crew had set their nets at Barry Bay, but in the gathering darkness they decided to leave the fish in the nets overnight. Now we would "cut out" the nets by pulling them up into the skiffs, and after the fish were bailed into the runboat, we would make another haul somewhere else.

We headed northeast toward Barry Bay under a cradle moon, the pounding sounds of the engines

barely drowning out the shrieks of the gulls that raced alongside, now ahead of us, now falling behind. Accompanying us on *Miss Olivia* was Danny Mason, the captain of the crew, along with Hugh Styron and Shane Moldenhaur. Captain Johnny Willis, Brandon Gavetti, and Luke Salter were aboard *Haulboat*.

The boats reached Barry Bay shortly after 7:00 A.M. with the sky brightening as the sun slowly climbed into the blue. Some of the crew from both boats poled themselves over to the nets and spent the next few hours pulling them up. The circle of net grew smaller and smaller. The runboat *Miss Bettie* arrived with Larry Gray at the wheel. I jumped from *Miss Olivia* to *Miss Bettie* to wait with Gray for the crew to finish their work. A pod of porpoises suddenly breached nearby, their sleek, glistening bodies breaking the surface in a dark arch of casual speed and power. Their breaths sounded like the snuffling of a dog. Once the bunt net was attached, *Miss Bettie* moved into position. Danny climbed onto the runboat and began to use the bailing net to transfer the fish into *Miss Bettie*'s hold.

The haul was a small one, and Gray left. The crew pulled the remaining nets aboard the skiffs and changed out of their wet clothes. It was only about 11 o'clock.

"I really thought we were going to have some fish," Danny muttered. "I don't know what's going on."

The shallow Core Sound and the other North Carolina sounds are gigantic nurseries for many of the most important commercially caught fish along the East Coast, including spots, weakfish (gray trout),

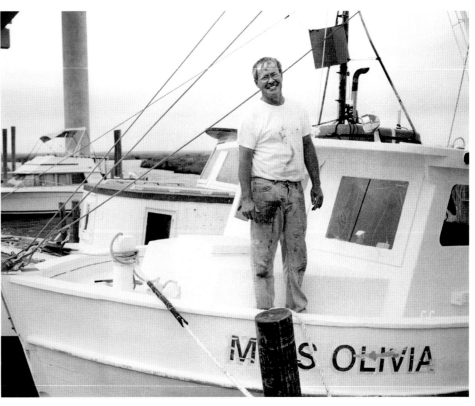

Danny Mason aboard
Miss Olivia, 2007

speckled trout, bluefish, croaker, flounder, menhaden, shrimp, blue crabs, and other species. They spawn in the ocean or around inlets, and the larvae and juveniles fatten up in the sounds in the spring and early summer. Many of these species end up in the nets of long-haul fishermen.

Some species are not commercially valuable. One June night, I called Danny late and asked him how he had done that day. "Three words," he replied, "wind, sharks, and rays." Cownose rays and stingrays are not commercially valuable, but scores of them

may be bailed along with fish into a runboat in the spring and summer. The fishermen have to toss them overboard. Small sandsharks lodge themselves in the nets and have to be removed by hand. A haul of menhaden may not be worth sending to the fish house.

Other species caught in the nets are protected by law. At certain times of the year, the nets can pull up loggerhead sea turtles as well as red drum. Sea turtles must be released alive, and so must red drum if they are smaller than 18 inches and larger than 27 inches. Weakfish (gray trout) are quite valuable commercially, but regulations tightly govern the size of the fish that can be sold. While long-haul bunt nets now have plastic rings to allow undersized fish to escape, some inevitably end up in the haul and are discarded at the fish house. Such unintended "bycatch" continues to be controversial despite efforts to keep it to a minimum. With only a few crews long-hauling compared with years past, the fishery is placing much less pressure on Core Sound fish populations.

Fall is the season for which long-haul fishermen live, when the spots have fattened and are migrating in schools through the sound. Danny says he can make a year's work in a single day with a good haul. For all fishermen, not only long-haulers who are looking for schools of migrating fish, fish movements are one of life's greater mysteries. But since long-hauling is a mobile operation, deciding where to set nets tests a captain's competency, and inevitably the word "luck" is used to describe why one trip is successful and another is not.

One fall Sunday morning, off Harkers Island,

Danny found no fish but returned to the same place that evening and threw a net overboard to test for the presence of fish. The fish were there, and he caught 2,200 boxes of big spots that evening—220,000 pounds of fish, one of his biggest hauls ever.

"If we had waited until Monday morning, the fish probably wouldn't have been there," Danny said.

Fishermen know that success is never guaranteed no matter how good the fisherman or his instincts. For long-haulers, disappointment is multiplied by six (the number of the crew), plus the runboat captain, the fish house workers, the fish house owners, and their families. All of them depend on the haul. Traditionally, the money from the haul is split between the captain and the crew, with a half or less going to the captain and the rest split among the crew. Too many lean hauls, and a captain will find it hard to keep a crew. Too many lean hauls, and a fish house owner will find it hard to keep his fish house open.

Danny wasn't sure what to do after this lean haul. He didn't want to waste a day by returning to the dock. He radioed a friend in Atlantic who said that flounder fishermen near Portsmouth Island that morning had reported a good sign of spots. Portsmouth Island, situated between Ocracoke and the Core Banks, is about a two-hour run up the sound from Barry Bay. By the time the crew set out the nets, it would be early afternoon and they'd risk having to cut out the nets in the dark. Danny decided to take the chance.

Danny Mason has been a fisherman ever since high school, when he worked for his stepfather, Charley Taylor. After high school, he worked on boats

belonging to different fishermen and then he bought his own boats. He is fit for a man in his sixties, his hair bleached by the hundreds of hours he spends on the open water each year. He's bull-like in his strength, and his foghorn of a voice can cut through the pounding noise of the engines when he is directing younger crews in the water. Like many fishermen, he knows the shallow channels of Core Sound as if they were no more than paths in his backyard.

A good fisherman is someone who's "always thinking ahead," said Clay Fulcher, co-owner of the Clayton Fulcher Seafood Co. "He's thinking about where he's going to go next time, is he going to be there ahead of somebody else? You know one man can be satisfied with what he catches and what he does, and that's fine. And you got another one that's got more drive and more push and wants to catch more and do better."

That's Danny Mason. His crews generally have stuck with him over the years because he's known for his ability to find fish. Yet as fishing hauls have declined, even a good fisherman has had a hard time keeping a crew. Men will fish with him in April but leave in May to shrimp. With younger or less-experienced crews, things can go wrong more readily. Long-hauling done correctly is a dance of boats and skiffs moving in scripted patterns, now approaching, now passing, normally without shouting or verbal communication except for a few quiet words spoken on the radio. An inexperienced crew can cause confusion and shouting and bad feelings.

Until recently, long-hauling had been Mason's "full-time" job. More and more, it's a part-time endeavor. The long-hauling season lasts from April until the end of October, but Mason works through the winter months, too, oystering by himself or with his stepson, Mark. He dredges oysters when the season allows, and when the dredging season ends, he tongs oysters, manipulating the 10-foot, scissorlike tools by hand to hoist the bivalves from the water. The long, cold days on the water tonging oysters are increasingly exhausting.

■ ■ ■ By early afternoon, Danny and his crew had set their nets off Portsmouth Island, at a place called Evergreen. It's been a classic "haul" for generations. The word "haul" multiplies in the lingo of long-haulers. A catch is a haul. A fishing trip is also a haul, and so is the place where a haul is made. In the office of the Clayton Fulcher Seafood Co., the names of dozens of hauls dotted a large map of Core Sound. I jotted down as many as I could, adding others later as I discovered their names. Evergreen, Royal Shoal, Schooner Shoal, Whalebone, Katherine Jane, and Croaker Hole are among the hauls in the northern part of the sound, off Portsmouth Island, that have been fished for generations. Lower in the sound, near Atlantic, there's Shell Island, Shell Cover, Rumley Bay, Ira's, Haul's Point, and Barry Bay. Through Thorofare Bay into West Bay and Long Bay in Pamlico Sound is a constellation of well-worked hauls, some of them with odd vernacular names that beg for explanation: Nameless Bay, New Stump Bay, Log Bend, Mousey Rat, and Cow Turd. In the lower part

of Core Sound, off Marshallberg, are Benny's Pound, Jarrett Bay, Horsepen Slough, and Yellow Shoal.

A haul may be productive or unproductive at certain times of the year. Captains use their experience and knowledge of weather, tides, and wind conditions to predict the best chances of a good haul on a given day, in a given season, at a given location.

"For at least fifteen years, there are two places in this whole sound where we can catch fish in April—that's Barry Bay and Cedar Island Bay," says Danny. "That's it. We used to catch fish in Nelson Bay in April—by April 15, you go there and start catching fish. First day of May you may as well forget Cedar Island Bay—Cedar Island Bay is an April place! But for the last fifteen years or so, if you don't catch no fish in Barry Bay or Cedar Island Bay, you might as well hang it up. After the first day of May, you start catching fish in Shell Cove, and Cedar Island Bay completely cuts off. You can mark it on your calendar."

But in the fall of the year, as the fish migrate in and out of Ocracoke Inlet, Evergreen is a good bet. On this day in late October, however, the fishermen were fighting both the weather and the time. Clouds were moving in, the water had taken on a serious chop, and it was cold. I did not envy the fishermen who would be in the water before long.

"We'll do a short haul," Danny said. "We need to get the fish out before dark."

By 6:00 P.M., the sun was setting below a high bank of threatening clouds massing on the western horizon. There was still blue sky above us that acted like a large reflector, casting the lingering light onto the sound's growing swell and silhouetting the men in the skiffs. For the second time that day, Larry Gray arrived aboard the runboat *Miss Bettie*, and I boarded it.

It was dark by 7:00 P.M., and everyone except Johnny Willis aboard *Haulboat* was working the nets, either in a skiff or in water up to their chests. Something was not right, however, and the men strained to get the bunt net to the footing stake. Fish were escaping. Larry, the runboat captain, stabbed his light into the darkness to help out and fumed in a language at once poetic and profane. "Damn dark! And it's got to blow, too!" he shouted into the wind. "It can't be pretty. And it would have helped if there had been a clear night with the moon bright." The boat rolled as the wind blew and the water roughened. "This boat would roll in a bathtub," he shouted.

Finally the gap was closed, and the crew fastened the nets to *Miss Bettie*. Shane began bailing the fish into *Miss Bettie*'s hold, and Danny climbed aboard, worn out from his ordeal with the nets. He slumped against the hatches. Larry went to the cabin and brought him a Diet Pepsi and a sweet roll, nudging him with the food and drink. Danny's diabetes is a worry for his crew. Over the years he has had to be pulled out of the water several times, his blood sugar out of balance. Danny bent over for a few minutes; then he straightened, grabbed a shovel, and began flipping ice onto the fish in the hold.

It had been a long time for the crew to get to this point, from dark to dark—the darkness of 5:00 A.M. to the darkness of 9:00 P.M.—a lot of time speculat-

ing about what they were about to see, always hopeful for that 2,000-box haul, but always realizing that it could be a 20-box haul.

By 10:30 the nets were emptied, and Larry Gray and I were on our way back to Atlantic. Danny had decided that the boats would anchor in place so they could haul again the next morning. I stood at *Miss Bettie*'s stern with the engine loud in my ears, thinking about how this shallow body of water sustains all kinds of fisheries and all kinds of gear. What backbreaking and often boring work long-hauling was, I thought, starting with these early morning departure times and then the fifteen-hour workdays, only to start the whole round again the next day. Who could possibly look forward to it, especially with the uncertainty of the money?

"I'm not doing this for the money," one crew member assured me that day. "I've only made $6,000 this year, which is pitiful for the hardness of the work and for five months so far. You can't bring people to this kind of work." It would be his last year of working on a long-haul boat.

In the dark we could see the flickering lights of channel markers and the red, white, and green lights of half a dozen shrimpboats. They weren't going to work in the blow and had tied up for the night.

Over the engine noise, I shouted, "Look at all those lights!"

Larry snorted. "That's nothing," he said. "Used to be it looked like a city out there."

We docked behind the darkened Clayton Fulcher Seafood Co. in Atlantic at precisely 12:50 A.M. Nobody was there to greet us. "They'll wait till morning to unload," Gray said. I snacked and was in bed by 2:00 A.M.

Rising by midmorning, I wandered down to the docks and found the fish moving up the conveyor belt from *Miss Bettie* to the interior of the fish house. Men and women were sorting fish and packing them in boxes, culling out the small fish. Danny and his crew, meanwhile, were at Evergreen, where they had commenced another haul at daybreak. His catch that morning amounted to about 100 boxes of fish. Added to the fish he caught at Barry Bay and Evergreen the day before, the total for two long days of hard work was about 160 boxes of marketable fish (16,000 pounds).

When he returned to Atlantic, he found that Buster Salter had done even better. Just off from his alternate week stretch working aboard the Cedar Island–Ocracoke ferry, Buster had taken his boat to Barry Bay that Tuesday and had found signs of a lot of fish. He called his crew together, and they hauled there Tuesday afternoon and again on Wednesday. He pulled in nearly 800 boxes of fish.

"Buster didn't go out last fall but two or three days and we went every day and worked harder," Danny acknowledged. "But Buster in two or three days caught more fish than we probably did the whole fall. He's saying it was luck. I don't know what it was. The fish was there when he went to catch 'em, that's all I know."

A week later, I called Danny to find out how he had fared the previous week. Fish prices that week had

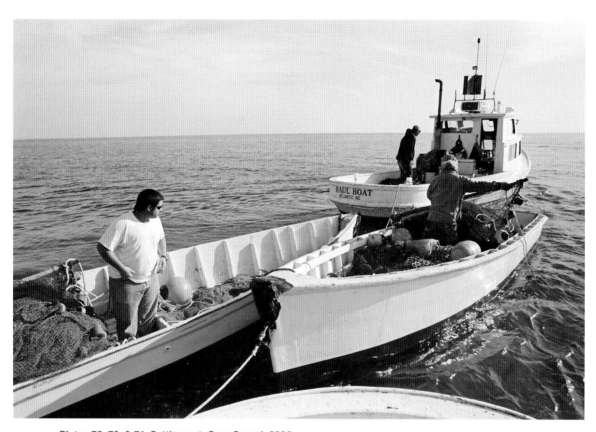

Plates 72, 73, & 74. Setting out, Core Sound, 2006

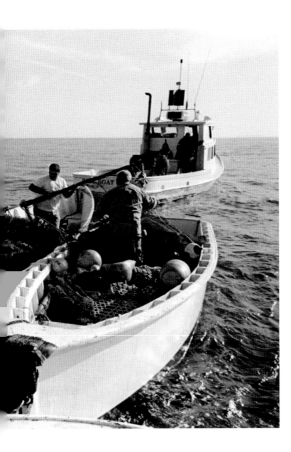

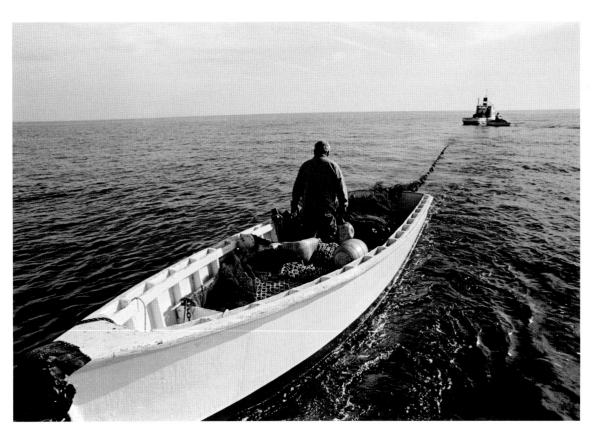

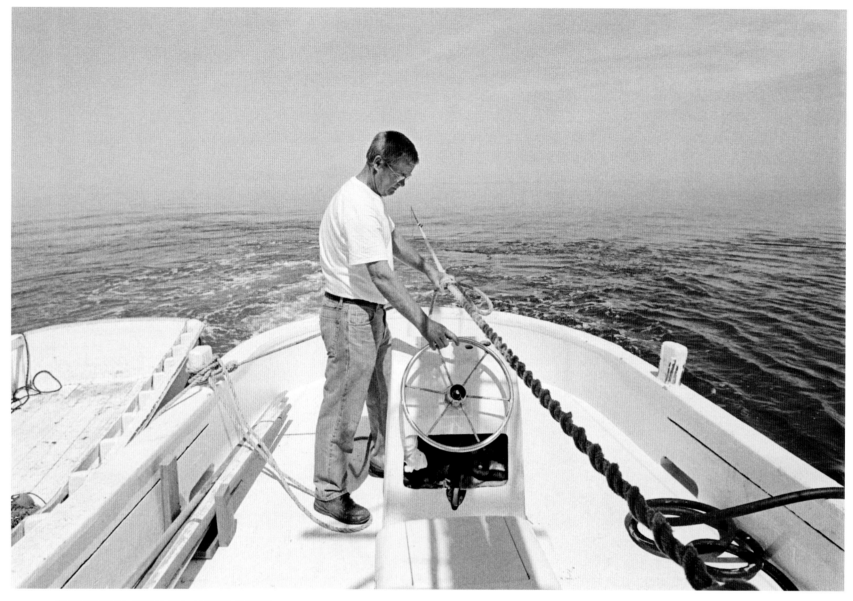

Plate 75. Danny Mason aboard *Old Salt*, 2006

My name is Danny Mason. I've been fishing most of my life, long-haul netting. Occasionally I'll shrimp a little bit. Sometimes I'll oyster a little bit in the winter. I got started with my stepfather when I was thirteen, fourteen years old. And I sort of grew up in it and I know more about it than anything else on the water and I'm sort of stuck into it. It seems like it's a dying process but I'm trying to hold on. It's hard to find a crew, and the price of fuel is going sky-high and the things we sell it seems they don't go up much.
—Danny Mason, Sea Level

Plate 76. Breakfast aboard *Old Salt*, 2006

Plate 77. Buster Salter and Gerry Barrett aboard *Miss June*, 2006

My name is John Salter, they call me Buster. I long-haul net fish, just like my family before me did. I been a-haul-net fishing since 1974, 1975, somewhere around then. It comprises setting out about three-quarters of a mile of net, pulling it maybe a half a mile, six-tenths of a mile apart, maybe pulling it anywhere from a mile to three miles. You have to know a little about the wind and the tides so that you can pull the nets—you can't pull them against the tide.
—Buster Salter, Atlantic

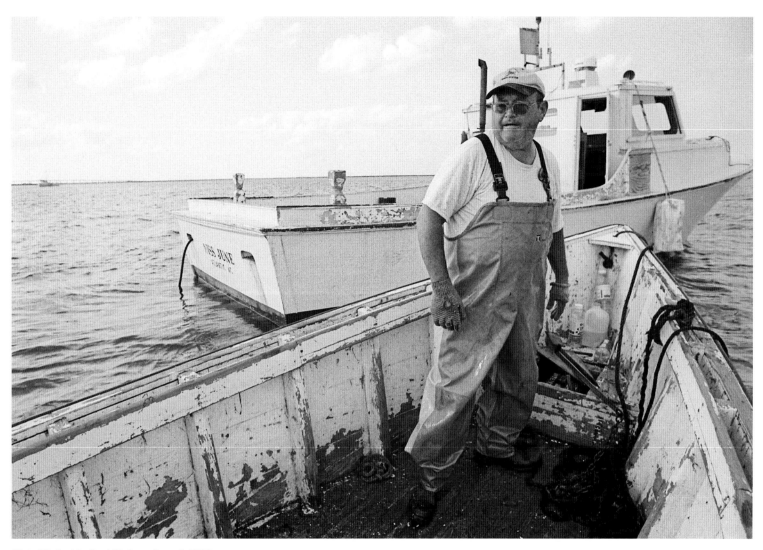

Plate 78. Buddy Gaskill, Core Sound, 2006

I was born on nine-eleven 1950. I started fishing when I was ten years old with my father, shrimping here in the sound. We used to pull ol' cotton nets. That's the reason why your boats had cockpits built into them. You plugged those off, mixed your lime and water, put your net down and wet that net in the lime, you know, and you hung 'em up to dry. If you didn't they'd rot. Same thing with the long-haul nets. They used to have to put 'em on spreads and lime them when they came in. They did that until the nylon came in in the sixties. You didn't have to do that then.
—Buddy Gaskill, Stacy

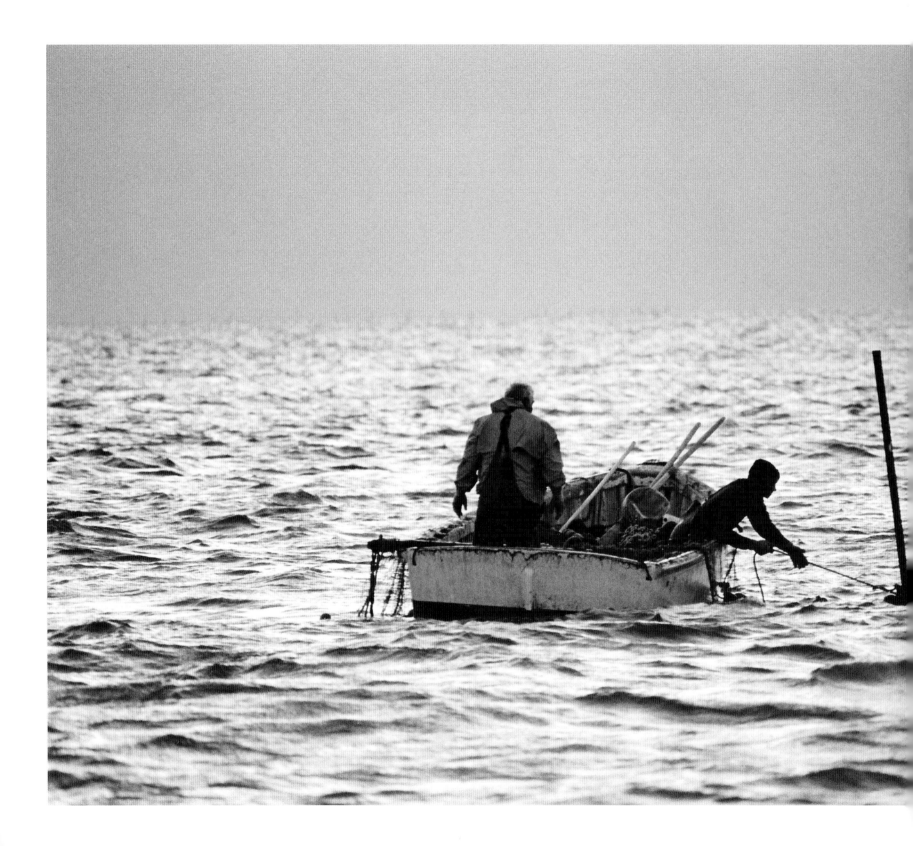

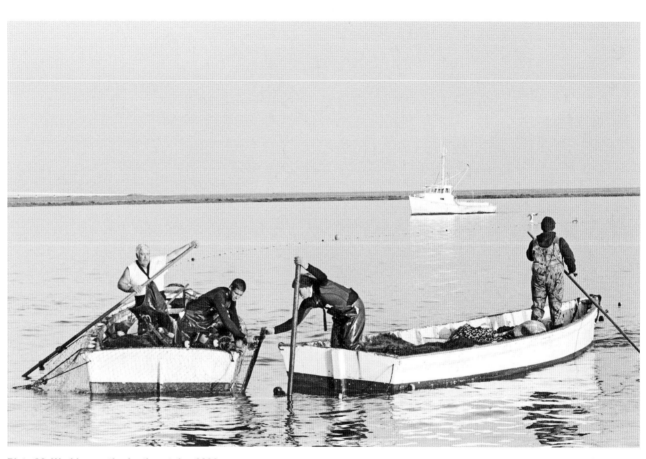

Plate 80. Working on the footing stake, 2006

Plate 79. Footing stake, 2006

119

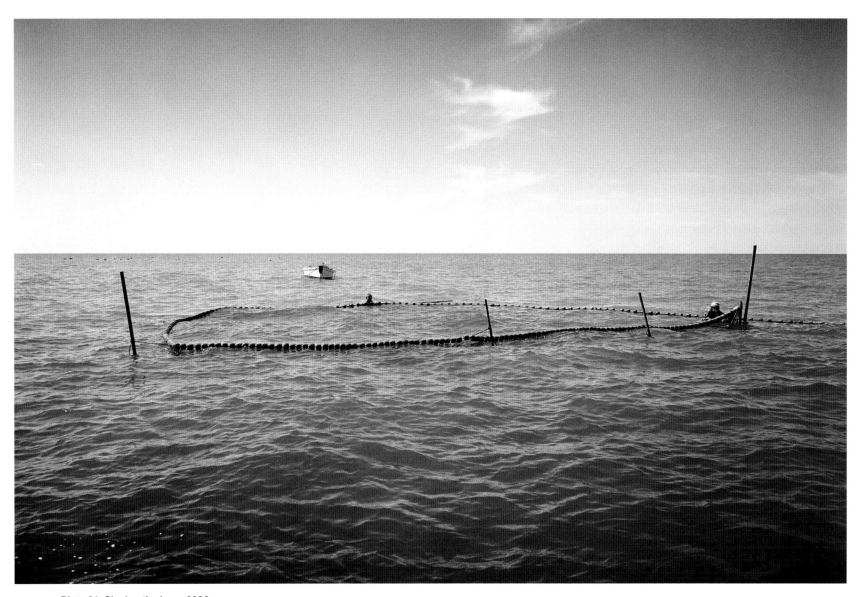

Plate 81. Closing the loop, 2006

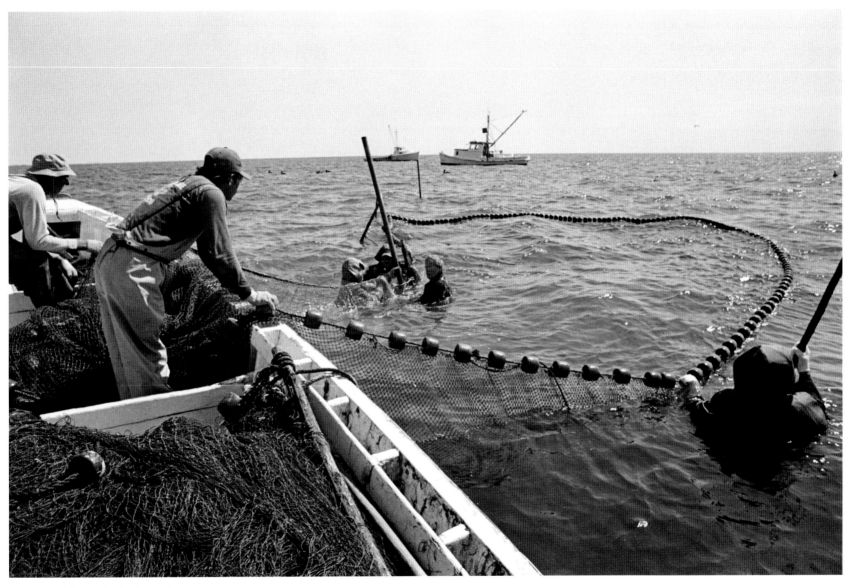

Plate 82. Bunt net, 2006

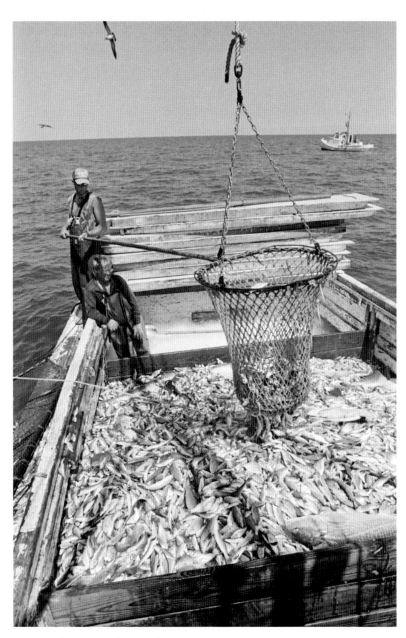

Plate 85. Bailing the fish, 2006

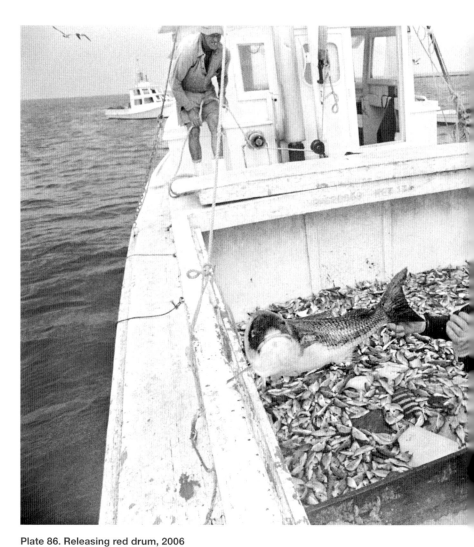

Plate 86. Releasing red drum, 2006

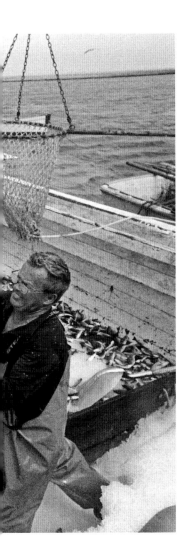

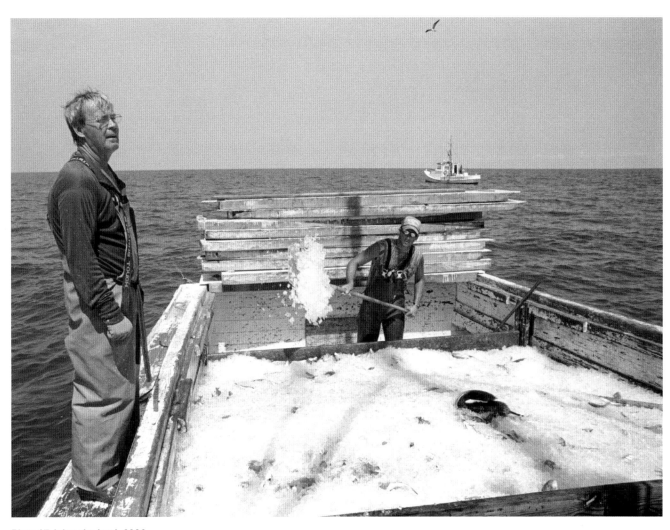

Plate 87. Icing the haul, 2006

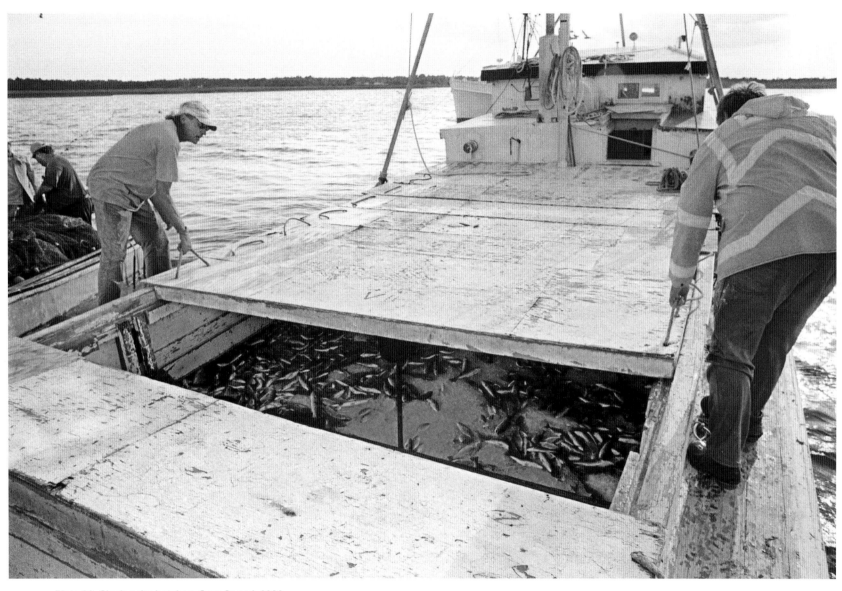

Plate 88. Closing the hatches, Core Sound, 2006

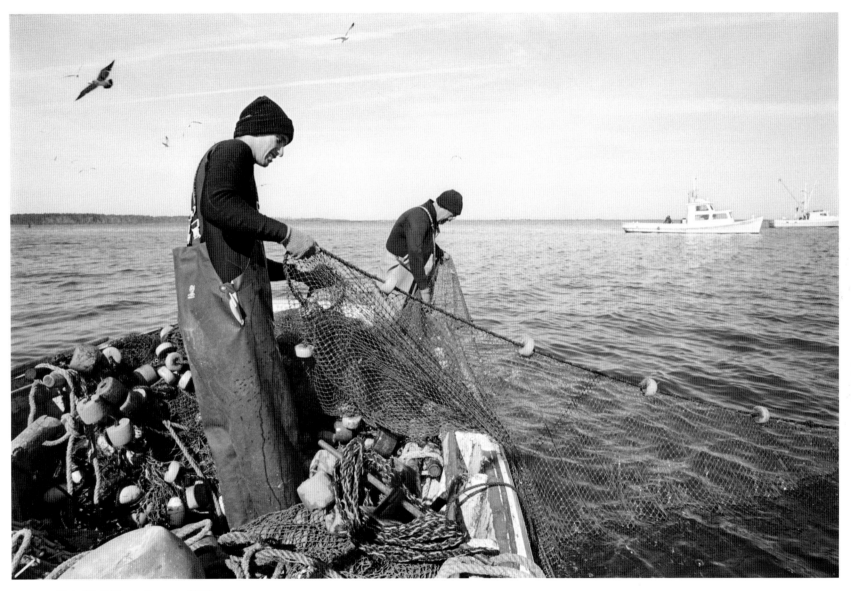

Plate 89. Taking in the nets, 2006

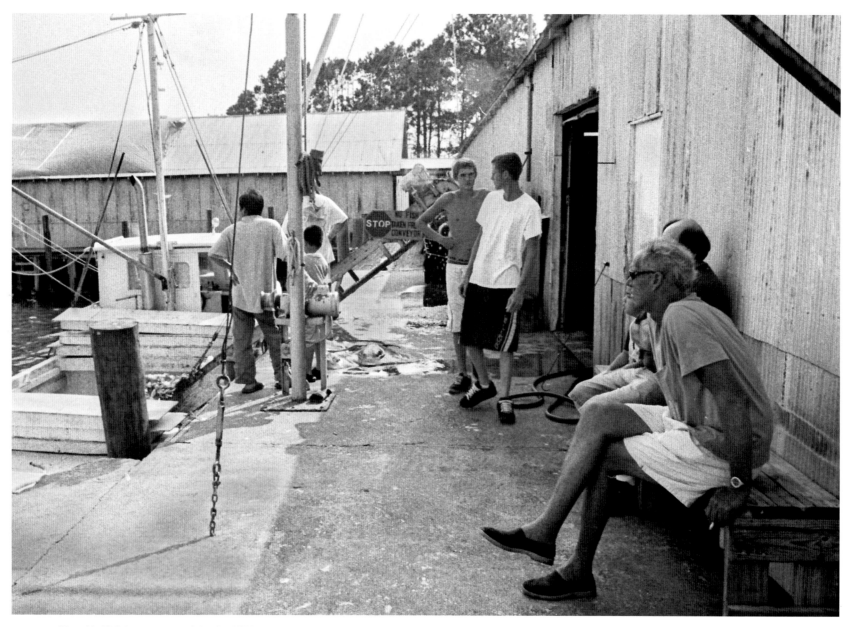

Plate 90. Fish house scene, Atlantic, 2006

Some of the older fellas would come down to the fish house and they'd say, "Is Danny hauling today?" and we'd say yeah and tell them where he's hauling, and they kind of knew that he might be in by four or five in the afternoon. We'd see a lot of them come down, circle around, see if they see a boat. They'll stop and ask have we heard from him. I noticed that over at Harkers Island the same way. Whenever the boat came in, everybody comes over with their pan ready to get some fish.
—Harry Michael Fulcher, co-owner, Clayton Fulcher Seafood Co., Atlantic

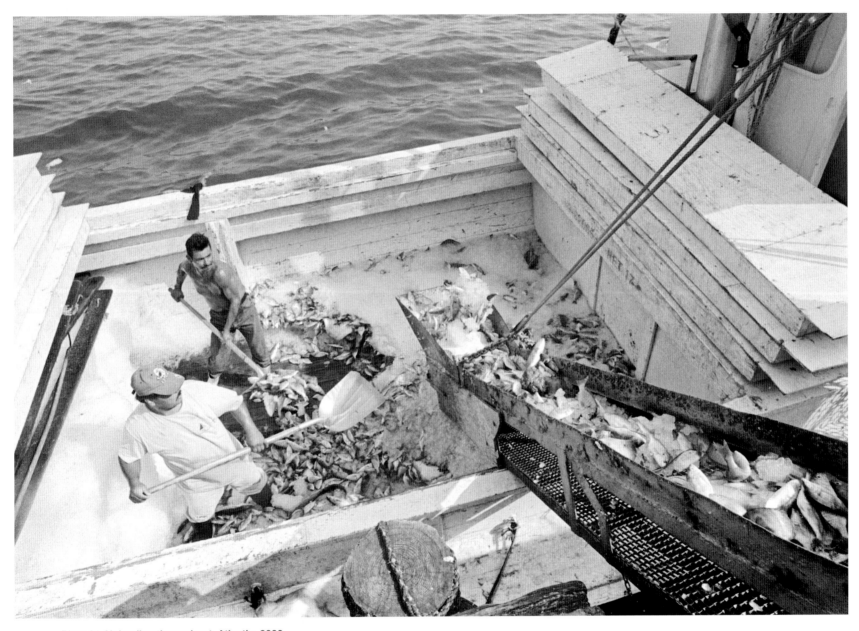

Plate 91. Unloading the runboat, Atlantic, 2006

A Changing World

It was as if they were mourning a death. The funeral was yesterday, the year before, a decade ago, but they still wore black.

"This young 'un won't have the same kind of life that Mike and I have had," said Ann Fulcher in Atlantic one day as she held her grandson in her arms.

"It's all changed, and the fish business is history," said James Paul Lewis of Davis during my interview. "I saw it come and go."

"You can't get nothing for what you catch no more," said Alton Chadwick in Marshallberg. "All the fish houses are closed now. Everything's gone. You got to go away from home now to get a job. I'm too old for that."

"I'm glad I got to live through the best times," said Charles Gilgo of Atlantic.

Little wonder that I began to feel a heaviness weighing on me whenever I drove into Atlantic. It had begun in 2007 when the Clayton Fulcher Seafood Co. closed suddenly. I had mistakenly thought of the Fulcher fish house as part of the town's permanent infrastructure, in the same order of importance as the school and the Baptist and Methodist churches. Clayton Fulcher, the fish house patriarch, was a pound netter from Bayboro on the mainland who moved to Atlantic in the 1930s and bought several small fish houses that occupied the space where Fulcher's stands today. At one point he had a buying station in Southport and one in Hatteras, Ocracoke, Cedar Island, Stacy, and Harkers Island. After he returned from World War II, Clayton Fulcher Jr. took over the operation from his father and was a prominent figure in eastern North Carolina in the 1950s and 1960s. The fish house once employed about fifty people full time and another fifty or so part time during the season to handle its business. In 1976, it processed between 5 million and 6 million pounds of fish, a million pounds of crabs, and 200,000 pounds of shrimp.

Yet Fulcher's was only one of a wave of North Carolina closings that had occurred in the new century. From 2001 to 2011, according to research by Barbara Garrity-Blake and Barry Nash for North Carolina Sea Grant, 36 percent of North Carolina's fish houses closed or were put up for sale. Most of them were in the central coastal region, where Core Sound is located.

A brief look at commercial seafood landings in

I loved to go down to the harbor, just sit on the dock and watch all the boats go out shrimpin'. But that's a thing of the past. They were so pretty leavin' the harbor and all. So many have just give it up.
—Berenice Goodwin, Atlantic

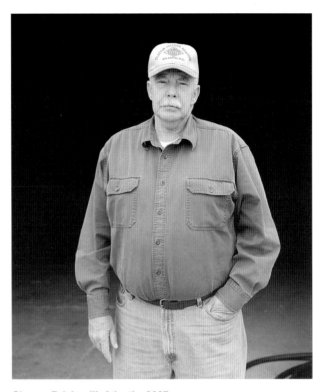

Clayton Fulcher III, Atlantic, 2007

Core Sound from 1962 through 2010 helps one to understand why so many fish houses have gone belly up. In 1962, fishermen caught 32,981,800 pounds of fish; in 1977, they caught 36,465,418 pounds; in 2010, 1,524,899 pounds. Fish landings are not a reliable measure of fish populations, but they do reflect fishing effort. It was clear that fewer fishermen were working on the water.

Other things were happening, too. Devastating hurricanes struck the region in 1999, 2003, and 2011. Increased water pollution from coastal development had closed productive oyster and clamming beds in the sounds. The Division of Marine Fisheries, the state agency that manages fishing in North Carolina coastal waters, installed increasingly restrictive limits and seasons on many species to prevent overfishing and help depleted stocks recover. Fish farms around the world were flooding U.S. markets with cheap fish. Diesel fuel costs rose considerably while prices paid to fishermen remained the same or even declined.

I would hear fishermen talking about it in Atlantic. "You can't make money on a dollar and a quarter [per pound] shrimp and $2.25 [a gallon] fuel," they would say. A couple of years later, diesel fuel had risen to more than $4.00 a gallon and hovered there for years.

Whatever the reason, there weren't enough fishermen on the water and fewer fish coming in to keep the Clayton Fulcher fish house open. The closing shocked some in the community. "When I found out that the Fulchers were closing, I just sat down and cried," said Janice Smith, widow of Billy Smith, who operated the Smith fish house until his death. "I rode by [Fulcher's], but I didn't go in. I didn't think I could handle it." I might have been surprised by the closing myself, but I had been hearing rumors about that possibility for almost a year. It further confirmed to me the shaky ground on which Core Sound's commercial fishing industry stood.

Some fishermen acknowledged a certain satisfaction over the Fulchers' closing, citing their age-old suspicions about the fairness of a system in which the operators set prices for the fish that they buy from the fishermen. "Fish houses cheat, they can't help it,"

one said. "If a preacher bought a fish house, he'd be cheating you within a week."

The truth was that the fishermen needed the fish house as much as the fish house needed the fishermen. Any closing was bad news for their communities.

Broader economic changes also lay behind the anxieties of the time, capped by the Wall Street–induced meltdown of 2007–8, after which real estate prices plummeted as much as 25 percent in coastal areas and halted, at least for a while, the speculation in real estate that had marked the mad years. "For Sale" signs sprouted on lawns throughout the town during the recession, but few houses sold. Though located on a prime waterfront lot, the Clayton Fulcher Seafood property in Atlantic remained unsold well into 2012.

■ ■ ■ Down East communities have faced many challenges over the years. Hurricanes are not new, and changeable fish harvests have been a fact of life for as long as men have fished in Down East waters. Many fishermen continue to believe in a cyclical theory of fish harvests, saying that the lean harvests today may just be a low point in the cycle of fish populations and that the fish will come back. Their fathers and grandfathers experienced similar booms and busts and adapted by turning to other fisheries, moving to Florida and Louisiana to fish, or taking up another trade until the fish came back. When they did, neglected boats or boats that had sunk at their moorings were raised, repaired, and fished again.

But for many, the old assurances that the fish would come back didn't seem to be as comforting as they had been in the past. "Somethin' wrong," Danny Mason told me one day. "In the early sixties, my stepfather had a boat named the *Ruth*," he said. "Fishing was so sorry then that he sold the boat to a fella here to Sea Level named Robert Daniels and went back to being a full-time carpenter. That lasted about three years. And then he went to Stacy and bought the old *Aileen*. When he bought that boat in 1964, he made a meager living with it for years and then in the seventies and eighties the whole world turned to fish. In a fifteen-, twenty-year period there were plenty of fish. And now we're on the decline again. Hopefully it'll come back, but I'm not sure it will."

Another long-haul fisherman, Buster Salter of Atlantic, looked at the problems from a different perspective. He had been involved with fishermen's issues at one time and contributed a lasting innovation to long-hauling by introducing large plastic rings into the mesh of the bunt nets to enable smaller fish to escape and thus to reduce bycatch. Over time, he grew dismayed by the regulatory burdens imposed by the Division of Marine Fisheries and the Atlantic States Marine Fisheries Commission and the rulebook that had grown encyclopedic. And despite the restrictions and regulations, fish populations still declined. "I understand that there have to be some rules that hurt," he said, "but they got to understand that these fishermen are trying to make a living, raise children, and send them to college. They want the same thing that the guy working in a factory wants."

Worse, he believes, are the larger environmental challenges that overshadow anything the fishermen or regulators could do.

"Something is going on in our world," he said.

These ice caps have been here for hundreds of thousands of years and all of a sudden they are melting to the point where you can see the soil. Something is going on. People don't want to hear it, but it's global warming. As the water temperature heats up, the sea levels rise. The temperature of the water affects spawning. Just like crabs—the water's got to be the right temperature for the crab to shed to make a soft crab.

Even if there were no fishing whatsoever, the fish won't come back until we change our ways and stop putting carbon into the atmosphere.

I talked with Jonathan Robinson of Atlantic for a few hours in the summer of 2012 to learn his ideas about the future of commercial fishing in the Core Sound region. Robinson's father, grandfather, and great-grandfather were fishermen and boatbuilders, and he himself was a long-hauler for most of his life, although he hasn't depended on fishing for several years. He served a term in the N.C. General Assembly from 1995 to 1996, and since 1998 he has represented eastern Carteret County on the Carteret County Board of Commissioners.

Robinson recalled being young and in love with the water. He had gotten his degree at N.C. State Uni-versity but returned to Atlantic to fish because he loved the life of a fisherman. He was surprised to find out he could make almost as much money fishing as his college professor was making in the classroom.

"It wasn't really that much, but it was enough to turn a young man's head," he said.

And there was a certain romanticism about being on the water fishing and being independent. Not too far in the past it didn't require a whole lot of capitalization to go into business.

Now remember I'm sixty years old. I'm facing the twilight of my life here. An elder person may not see things in the same light that a young person does. But it's real hard for me to be optimistic about the inshore fishery. How could you be an optimist?

Yet if I were a young man, I'd probably want to do it again.

Of course, not every man in a traditional fishing community chooses to be a full-time fisherman. This is certainly true today, but it was equally true in the years after World War II when jobs transporting tourists aboard ferryboats sprang up, and especially when the Marine air station at Cherry Point opened in 1942. It and other mainland employers offered men a reliable income, a paid vacation, health care, and more time with their families—benefits never offered by commercial fishing. Some of these men kept close to the water. They fished or shrimped during

their off time. They built boats or sold model boats or decoys for a living. But they were no longer full-time watermen.

Buddy Gaskill of Stacy is one of the men who chose a different life for himself and his family. I met him in 2006 when he was a member of Buster Salter's long-haul crew. He was helping out for the week, rounding out Buster's crew. But he had been an engineer on the Cedar Island ferry for two decades, working a week on and a week off. He has not regretted the decision he made long ago.

"I'll tell you what, fishing is the most enjoyable life I ever had, a full-time commercial fisherman," Buddy told me.

But I work on the ferry at Cedar Island now. I went there about 1984 because I had kids coming up, bought a home in Stacy, my wife was having babies and so she wasn't working at the time, and it got slack.

I was over on the Pamlico River on the ferry then, and I wasn't making a whole lot of money. The scallopers were making some money and I called Billy Smith in Atlantic about getting on one of the scallop boats.

And he asked me then, Mr. Billy did. He said, "Buddy, you haven't quit your ferry job, have you?" I said, "No, not yet." And he said, "And you better not, because this is gone."

He saw it right then, he saw the writin' on the wall right then.

■ ■ ■ I used to smile when I drove into Atlantic and read the town's proud slogan on its greeting sign: "Atlantic—Living from the Sea." It was such a confident, almost swaggering boast, the community's declaration of independence, and it could well have summed up what other Down East communities wanted as well. But one day in 2012, I noticed that the sign had been altered. It now read "Atlantic. Settled 1740. Inc[orporated]. 1905." The slogan was missing. What its removal suggested about Atlantic's fortunes as a fishing community might not have been intentional, but it could hardly have been more accurate.

In retrospect, what may be more significant about the changing economic life of Down East communities today is not that the fishermen are turning to other ways of making a living, but that so many have survived as fishermen for so long.

Epilogue

In early 2012, I discovered that several boats that I was familiar with had vanished from their customary spots in Atlantic's harbors. *Hazel* and *Linda* were gone from their slips behind the Smith fish house, and at the county harbor, *Harry B.*, the seventy-five-year-old, Ambrose Fulcher–built runboat, had vanished as well. Over the years, of course, many workboats that I photographed have disappeared for one reason or another. Listed below are some of them.

Bettie E.	Atlantic. Sold by Clayton Fulcher Seafood Co. in 2007 to a tour boat operator in Little Washington.
Capt. Clayt	Atlantic. Sold by Clayton Fulcher Seafood Co. in 2007 to a new owner on Harkers Island.
Capt. Jim	Williston. Neglected and went to pieces.
Luther Lewis	Davis. Sold and left the area.
Miss Lue	Davis. Sold and left the area.
Harry B.	Atlantic. Sold by Clayton Fulcher Seafood Co. in 2007 after the fish house closed. It was neglected and sank in Atlantic Harbor.
Hazel	Atlantic. Sold in 2011; engine removed; hull destroyed by Hurricane Irene in 2011.
King Fisher	Davis. Derelict in Davis Harbor for many years until 2012, when it was hauled from its slip in the harbor and taken to the dump.
Linda	Atlantic. Bilge pump failed in 2007; destroyed by Hurricane Irene in 2011.
Miss Bettie	Atlantic. Sold by Clayton Fulcher Seafood Co. in 2007.
Wasted Wood	Atlantic. Neglected; went to pieces in a marsh in the late 1990s.

Two other Core Sound workboats underwent changes of a very different kind. The old boats might well have succumbed to neglect or a hurricane, like *Linda* or *Wasted Wood*, but there they were, looking spruce and well kept—better, indeed, than they had in a long time, with fresh coats of paint and new boards and gear. And, as if reinforcing the Phoenix-like symbolism of the moment, their reappearance

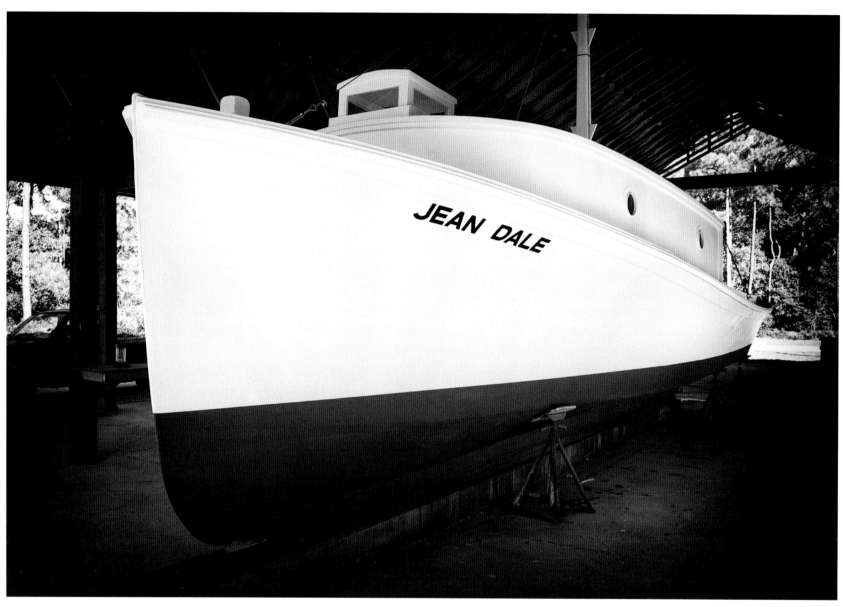

Restored *Jean Dale*, Harkers Island, 2010

occurred in the same month and year, and in two Down East communities with long heritages of boatbuilding and fishing.

On Harkers Island, early in September 2010, Jimmy Amspacher completed his restoration of the sixty-four-year-old *Jean Dale*. The sink netter had been slowly disintegrating since Harry Lewis, the owner, had stopped fishing. In 2000, Lewis's family donated *Jean Dale* to the Core Sound Waterfowl Museum and Heritage Center on Harkers Island as an example of the island's boatbuilding heritage. The old wooden boat showed the scars of a long working life and had tales to tell—of burning up once while fishing, of sinking twice.

It was so badly out of plumb that the first thing Am-

spacher had to do was let it sit for almost two years trying to get it back to square. In late 2009, he began renovating the boat. He stripped the paint, removed the rotten boards, rebuilt the cabin, and gave it a new coat of paint. When he was finished in the late summer of 2010, *Jean Dale* looked like the beautiful Core Sound workboat that had become a legend.

The museum threw a party to celebrate not only the occasion but also the tradition of boatbuilding on Harkers Island. All day long they came, men, women, and children, singly and by the carload. There were fishermen and boatbuilders, residents of Harkers Island and off-islanders. They had a celebration on their minds, and they went about it with gusto, gazing at the pretty workboats that had been trailered into place outside the Core Sound museum, wolfing down mullet, bluefish, slaw, and hushpuppies and sipping sweet tea. Inside the museum, they talked to boatbuilders and examined displays, photo albums, videos, and artifacts. And then they wandered back outside again to gawk one more time at the old boat itself.

Inside, convened by Karen Amspacher, the museum's director, a panel of boatbuilders discussed *Jean Dale* and the legacy of Harkers Island boatbuilding. Linwood Parker, owner of Parker Boats of Beaufort, remembered that when he was a child on Harkers Island, boatbuilding was everywhere. He and his friends could walk from one end of the island to the other along the shoreline, where the fishing

nets dried on the net spreads, and observe a couple of dozen people building boats from scratch. At the country stores, they'd overhear conversations about who was building and about the boats' dimensions and their stages of construction. And when a boat was launched, the instant critiques came fast: "Too high on the bow." "Just right." "Sheer looks good." "Sheer doesn't look good."

"And then you say, this looks good to me and this is why," Parker said. "And then you get the opportunity to go build one yourself. It wasn't a matter of purchasing a boat. You did it yourself."

The Lewis family boatbuilders—brothers Houston and Jamie and Jamie's son James—recalled how boatbuilding on the island had changed over the years. More and more customers wanted boats with slick finishes. "We had to compete with fiberglass boats and they were just like glass, you know," said Houston, ruefully. "It's hard to get a wooden boat like glass."

In recent years, added his brother, Jamie, "We've built very few workboats. We built a few in the last couple of years for some local people, but nowadays it's all sportboats. You're talking about a whole different boat when you're building a sportboat."

■ ■ ■ In Atlantic, a few weeks later, another old boat took on a new life. Five years before, the eighty-three-year-old long-haul boat *Nancy Ellen* had been lifted from the harbor and deposited beside the fish house. Over the years, I had watched and photographed

David Smith as he worked on it. The boat had a distinguished history in Atlantic. Built by Ambrose Fulcher in 1927, it lay derelict in the harbor of the fish house in 1954 when Charles Smith, David's father and one of Atlantic's premier fishermen, bought it. After Dennis Robinson, an Atlantic boatbuilder, finished rebuilding the boat, Smith renamed it *Nancy Ellen* after his two daughters. He used the vessel (and the *Wasted Wood*, which he also owned) in his long-haul operations until 1979, when he sold both to Buster Salter. Salter had Marvin Robinson, Dennis's son, rebuild it, and he used the *Nancy Ellen* to long-haul for many years. David Smith bought the vessel from Salter in 2005 and began to rebuild it all over again.

When he stripped the paint from the hull early on, he found that the old timbers were springing loose almost as the paint came off—the paint seemed to be the only thing keeping the boat together. After replacing the nails with screws and puttying carefully around each nail hole and deep into each gouge in the old timbers, he epoxied the hull. He also rebuilt the cabin and moved it to the rear of the boat—"to get away from the stink and the sound of the engines," he said.

One day in late September 2010, David called to invite me to the launching of the new *Nancy Ellen*. I arrived in time to see George Brown drive a monstrous crane to within a few yards of the boat. After adjusting the giant crane's support pods to fit the uneven terrain, David and George passed two wide canvas straps hung from the crane across the boat's bottom,

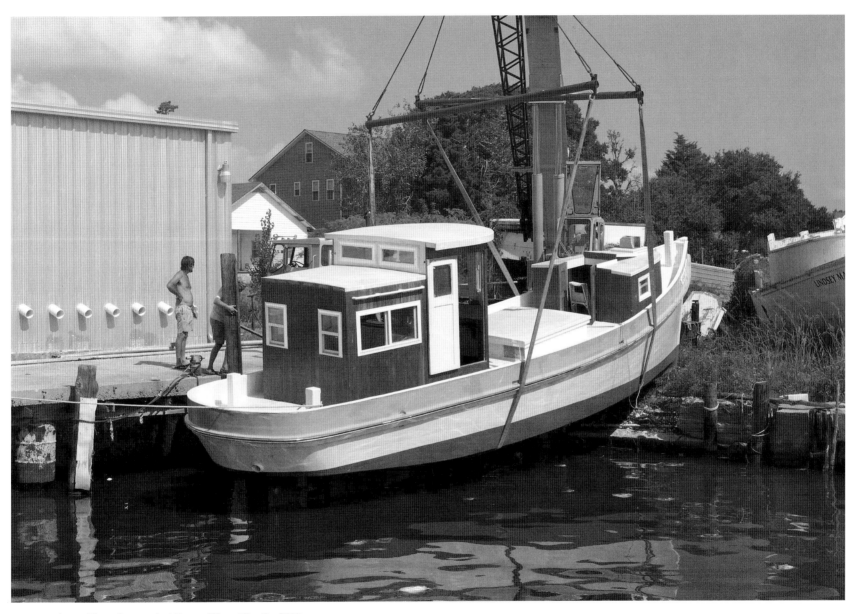

Launching of renovated *Nancy Ellen*, Atlantic, 2010

About the Photographs

Plate 1. *Katrina Ann*, Cedar Island, 1992. Built by E. B. Tapscott in 1987, shrimpboat *Katrina Ann* was previously named *Anne Marie*. The boat is owned by Stewart Payne of Sea Level.

Plate 2. Thorofare Bay, 2011

Plate 3. Highway 12, Cedar Island National Wildlife Refuge, 2007

Plate 4. Mosquito ditch, Stacy, 2007

Plate 5. Marsh fire, Cedar Island National Wildlife Refuge, 2007

Plate 6. Juncus Marsh, Davis, 2007

Plate 7. Down East, 2007

Plate 8. Stacy Cemetery, 2007

Plate 9. Davis, 2006

Plate 10. Sea Level, 2006

Plate 11. Harkers Island, 1995

Plate 12. Sign in Atlantic, 2007

Plate 13. House in Atlantic, 2007

Plate 14. Atlantic Harbor, 2007

Plate 15. Fogbound, Atlantic Harbor, 2007

Plate 16. Maritime forest, Atlantic, 2006

Plate 17. Hidden house, Atlantic, 2007

Plate 18. Hunting Quarters Primitive Baptist Church, Atlantic, 2006. The Primitive Baptist Church in Hunting Quarters (later Atlantic) was organized in 1780, and its first church was built on the waterfront in 1829. After the structure was destroyed by a storm, Lemuel H. Hardy, pastor of the congregation, donated land in 1918 for a new church to be built next to his house on Shell Road, where it still stands. The church fell into disrepair after the congregation died out. Today, renovations on the old church are proceeding. It is used as a museum and meeting place for the Atlantic Historical Society.

Plate 19. Leonard Goodwin's pound net, Atlantic, 2006. Pound nets are traps consisting of a long entranceway ending in a wider enclosure called the "pound." The fish swim along the entranceway into the pound and cannot return. Long-hauling and other fisheries require several large workboats and up to six or seven men, but pound netting can be practiced by one or two fishermen. Yet it takes a large effort to place the nets in the water. Pound netters sometimes need as many as 400 to 500 stakes, gum saplings that they drive into the sound bottom to provide the framework for the nets. Hurricanes often destroy pound nets.

Plate 20. Leonard Goodwin mending pound net, Atlantic, 2006

Plate 21. Leonard Goodwin's tar rig, Atlantic, 2006. During the off-season in winter, some fishermen

clam or oyster to make some money. But this is the season when they mend and tar their nets in preparation for the new season. They also paint their boats at this time.

Plate 22. Waterfront, Atlantic, 2007

Plate 23. *Miss Kailyn* coming in, Atlantic, 2006

Plate 24. Smith fish house, Atlantic, 2011

Plate 25. Mending net, Sea Level, 2006

Plate 26. Mending net, Atlantic, 2010

Plate 27. Ice, Smith fish house, Atlantic, 2007

Plate 28. Hauling *Amanda Jean* onto railway, Smith fish house, Atlantic, 2007

Plate 29. Drink machine signs, Smith fish house, Atlantic, 2011

Plate 30. Clayton Fulcher Seafood Co., Atlantic, 2007. Once a highly profitable fish house, the Clayton Fulcher Seafood Co. closed in 2007 after many years of declining fish catches.

Plate 31. Winston Hill Store, Atlantic, 2011. Winston Hill Store was once a popular general store on Seashore Road in Atlantic that sold groceries, hardware, kerosene, paint, oars, gasoline— everything that a fisherman or a fisherman's wife might need. The store closed in the 1970s. Early in the century, an oyster factory was erected on the site.

Plate 32. *Wasted Wood* coming in, Atlantic, 1985. Will Mason built *Wasted Wood* in 1933 for the long-haul fishing trade. In the 1950s, Charles Smith of Atlantic bought it and had the boat substantially rebuilt. He renamed it *David M.* for his son. In 1979 John "Buster" Salter purchased the boat and fished it until the late 1990s. The second workboat is *Linda*, built by Ambrose Fulcher of Atlantic in 1939 for

John Weston Smith, who named it for his daughter. It was a runboat that fetched fish caught by long-haulers.

"That's the *Wasted Wood* and that's the *Linda* right there behind her. And this old haul net skiff is one that Charles Smith had, and it was the *Hetty Jane*. Why he named it that, I don't know. The *Wasted Wood* was built about 1933. Will Mason built it down there by Luther Smith's fish house. Built it by himself and put it over by himself." (Buster Salter, Atlantic)

"I was talking to another fellow about *Wasted Wood* and we came up with a list of about seventy men who were connected to her in some way. People look at her and see an old boat, not much at all. But that boat brought in no telling how many hundreds of thousands of pounds of fish to this community over her lifetime, and no telling how much money. She was responsible for the livelihoods of dozens of families in the community. And the same could be said about other boats." (Jonathan Robinson, Atlantic)

Plate 33. *Old Salt* coming in, Atlantic, 2006. Ambrose Fulcher built the 39-foot-long *Old Salt* for Harman Hill of Atlantic in 1919. Originally named *Aileen*, after Hill's daughter, it is possibly the oldest fishing boat still in operation in Core Sound. *Aileen/Old Salt* has had several owners over the years. In 1965, Charley Taylor of Sea Level bought the boat to use in his long-hauling operation. Taylor's stepson, Danny Mason, took it over later and made

extensive repairs. He renamed the boat *Old Salt* after his uncle and still hauls with it.

Plate 34. *Miss June* coming in, Atlantic, 2005. Clarence Willis of Harkers Island built this boat in the 1990s. It is owned by John "Buster" Salter of Atlantic.

Plate 35. *Nancy Ellen*, Atlantic, 2006. *Nancy Ellen*, formerly named *Pauline*, was built by Ambrose Fulcher of Atlantic in 1927 for Irwin Morris, also of Atlantic. It was constructed as a haulboat for the long-haul fishing trade and named for Morris's niece. In the 1950s, Morris sold it to fisherman Charles Smith, who renamed it *Nancy Ellen* after his two daughters. In 1979, John "Buster" Salter bought *Nancy Ellen* for use in his long-haul fishing operation. In 2005, he sold it to David Smith, the son of Charles Smith, who remodeled it as a pleasure boat. As can be seen in the photograph, a "waist" has been added to elevate the boat's sides.

Plate 36. *Hazel*, Atlantic, 2006. J. W. Robinson and his son Dennis Robinson of Atlantic built *Hazel* in 1920 for the long-haul fishing trade. Jason Lupton and his son John of Cedar Island acquired the boat and worked with it for some time before selling it to John Lupton's son-in-law, Leonard Goodwin of Atlantic. Goodwin used the boat for pound netting. Jamie Chadwick of Beaufort lengthened the *Hazel*'s original stern by 4½ feet and also modified it by adding a deck and by squaring it off. *Hazel* has the high cabin characteristic of workboats built in Atlantic. *Hazel* was sold in 2011, its engine was removed, and in the same year Hurricane Irene sank the boat in Atlantic Harbor.

Plate 37. *Down East*, Atlantic, 2006. Marvin Robinson of Atlantic built the *Down East* in the mid-1970s with his son, Jonathan. Robinson had a reputation for building a boat with an exaggerated sheer— notice the high bow.

Plate 38. *Haulboat* (*Marian A.*) approaching, Core Sound, 2006. Core Sound workboats are so versatile they can be used in different fisheries. Ambrose Fulcher of Atlantic built *Haulboat* as a runboat in 1936 for the Clayton Fulcher fish house. It was originally named *Marian A.* for Fulcher's first child, Marian Agnes. When long-hauling declined in the 1960s, the Fulchers used the boat to trawl for shrimp. When long-hauling grew profitable again in the 1980s, it was converted back to a runboat. Danny Mason of Sea Level bought *Marian A.* in 1998 and renamed the boat. Mason uses it as one of his two haulboats.

Plate 39. *Linda*, Atlantic, 2007. *Linda*, here tied up at the docks of the Smith fish house in Atlantic, was built by Ambrose Fulcher in 1939 for John Weston Smith and named for Smith's daughter. *Linda* was built as a runboat but was also used for shrimping, clamming, and crabbing. Wooden workboats require constant upkeep, and sometimes the amount of work required exceeds the usefulness of the boat. In *Linda*'s case, the substantial overhaul the boat needed would not have improved its usefulness on the water, and it was allowed to go to pieces. Its bilge pump failed in 2007, and in 2011 Hurricane Irene destroyed the boat at the dock.

"The *Linda*'s been modified a little bit. She looks a little different than she used to. The stern was raked, it didn't turn up. They carried her to South River and had her redone, changed the

pilothouse onto her, put a plywood cabin onto it, put a pilothouse onto it, and moved the motor forward." (Buster Salter, Atlantic)

with the fish. They'd stay there for the night, go wash clothes, cook, do whatever they had to do." (Jimmy Amspacher, Marshallberg)

Plate 40. Clayton Fulcher Seafood Co. runboats, *Muriel* (front), *Bettie E.*, and *Harry B.*, Atlantic, 2005. "Runboats" or "buy boats" were sent by the fish houses to bail fish out of the nets of long-haul fishermen and bring them back to the fish house for packing and selling. They were larger than the typical haulboat, but they still could negotiate the shallow sound waters. *Muriel, Bettie E.,* and *Harry B.* were part of a runboat fleet operated by the Clayton Fulcher Seafood Co. of Atlantic. All three were built by Ambrose Fulcher of Atlantic in 1935, 1939, and 1938, respectively. Notice the sweeping lines (known as "sheer") of the 36-foot-long *Muriel*, a characteristic of Core Sounders in general and especially those built by Ambrose Fulcher.

"A lot of times I used to run the *Harry B.* When I was fifteen years old, I'd take that boat and head down to the sound. I'd leave home every morning about 2 o'clock and run down the sound because she wasn't fast. I'd ask them where are you going to be, and they'd say Evergreen Slough, Wallace Channel, Teachey Hole, Black Point, wherever. And I'd run to them. And the next morning about sunrise they had the nets out and they were already starting to come together. I'd load the fish off of her into the boat and they'd go out to make another set, and I'd lay up in the boat to go to sleep. And then about 4:30 or 5, I'd head back to Atlantic

Plate 41. Fulcher runboats, Atlantic, 2005

Plate 42. Runboat *Bettie E.* at Clayton Fulcher fish house, Atlantic 2007.

Plate 43. Rounded stern on *Harry B.*, Atlantic, 2006. Core Sound workboats were known for their rounded sterns. Inherited from the sharpie boat design, rounded sterns were preferred by fishermen because nets didn't snag on them. The metal object holding the ropes was called the quadrant. It was part of the tiller assembly. The steering lines ran from the pilothouse to the quadrant and then down the stalk to the rudder below. An outside steering line was easier to assemble and repair than one that was located inside the boat.

Plate 44. Runboat *Miss Bettie*, Atlantic, 2006. In 1980, James Gillikin Boatworks built the *Miss Bettie* as a runboat for the Clayton Fulcher Seafood Co. of Atlantic. It was named after Bettie Elizabeth Fulcher, wife of Clayton Fulcher. The Fulcher family sold *Miss Bettie* after the fish house closed in 2007.

Plate 45. Runboat *Kimberly M. Smith* (right) and *Our Kid*, Atlantic, 2006. James Gillikin Boatworks built *Kimberly M. Smith* in 1977 as a runboat for the Luther L. Smith & Son, Inc., fish house in Atlantic. Note the straight bow of this boat compared with the moderately flared bow of *Our Kid*. Both were built in Harkers Island, but the flared bow is considered a signature style of that community's

boatbuilders. *Kimberly M. Smith* was named after the daughter of Billy Smith, who owned the fish house then.

Plate 46. Runboat *Kathryn L. Smith* at Luther L. Smith & Son fish house, Atlantic, 2010. James Gillikin Boatworks built *Kathryn L. Smith* in 1978 for the Luther L. Smith & Son, Inc., fish house in Atlantic. It is about 47 feet long.

Plate 47. Runboat *Kimberly M. Smith* on rails at Smith fish house, Atlantic, 2006

Plate 48. Atlantic skiffs, 2006. Boatbuilders were as skilled in making skiffs as they were in constructing larger boats. Skiffs had become critical to long-hauling operations, where fishermen needed them to haul in the nets. In other fisheries such as mullet fishing and pound netting, skiffs were required as well. Once the fishing season ends, fishermen paint and repair their skiffs and make new push poles and oars.

Plate 49. Skiffs and net house, Atlantic, 1992

Plate 50. Two skiffs, Atlantic, 1985

Plate 51. Skiff in marsh, Atlantic, 1992

Plate 52. *Mary Elizabeth, Miss Rachel, Capt. Joe*, Cedar Island, 2006

Plate 53. *Hilda P.* and *Our Kid*, Sea Level, 2005

Plate 54. *Capt. Daily* (*Lavonne*), Sea Level, 2005. In 1969 or 1970, Carl and Charley Edwards of South River built *Capt. Daily* for Richard Hamilton of Stacy. Originally named *Lavonne*, the boat was used in the long-haul fishing trade. Keith Mason of Sea Level bought it in 1987 and renamed it after his wife's father, Daily Salter, a fisherman from Sea Level. In recent years, the boat has gone to pieces because of rot.

Plate 55. *Miss Sue*, Stacy, 2007. Calvin Rose of Harkers Island built the hull of the *Miss Sue* in 1962 for Monte Willis of Stacy. At 25 feet in length, the boat could be handled easily by one person. Willis used it for shrimping, scalloping, and oystering. In the early 1970s, Leslie Hamilton of Stacy built the cabin. In the late 1980s, fisherman Michael Braxton Fulcher of Stacy bought the boat and renamed it *Miss Sue* after his wife. He added the pilothouse later.

Plate 56. Workboat, Davis Harbor, 2007. Marvin Murphy used this boat for shrimping and clamming. The wooden workboats of Core Sound were handmade by an individual boatbuilder, not manufactured to a standard length and design, as are many of today's boats. Boatbuilders build a boat to satisfy their customers' needs, but they also build according to their own tastes and experiences.

Plate 57. *Kevin* and workboats, Davis Harbor, 2007. Fishing has been the most important part of the Down East economy for more than two centuries, and boatbuilding was a critical skill. Early twentieth-century boatbuilders like Ambrose Fulcher, Brady Lewis, and Mildon Willis built workboats with hand tools, often in their backyards. They followed no plans, using what they called "the rack o' the eye" to judge proportions and lines. In this photograph taken at Davis Harbor, the boats exhibit a variety of sizes and styles. A workboat reflects the purposes of the fisherman for whom the boat was built, the boatbuilder's individual style, and the traditions of the community in which the boat was built. Henry Fulcher of Atlantic built *Kevin* in the early 1970s.

Plate 58. Abandoned skiff, Harkers Island, 1995

Plate 59. *King Fisher*, Davis Harbor, 2007. Calvin Rose of Harkers Island built *King Fisher* in 1976 for the James F. Styron fish house in Davis. It was 37 feet long and 19 feet in the beam. The fish house used it initially as a runboat for its long-haul crews. After being unused for years, the boat was hauled from the harbor, its rigging and other hardware were salvaged, and the hull was brought to the dump in pieces.

Plate 60. *Capt. Jim*, Williston, 2007. Lloyd Willis of James Gillikin Boatworks built *Capt. Jim* for James Paul Lewis of Davis. It was one of a fleet of trawlers operated by Lewis. Because of neglect, the boat began to fall apart and finally was hauled out of the water. It sat here for some years before it was broken apart and its pieces removed.

Plate 61. *Luther Lewis* at oyster house, Davis, 1985. Lloyd Willis of James Gillikin Boatworks built *Luther Lewis* as a shrimp trawler for James Paul Lewis of Davis in the 1970s. Lewis named the 60-foot boat for his father. The boat was photographed at the dock belonging to the Luther Lewis Seafood Co. in Davis. Other trawlers that Willis built for the fish house were *Miss Lue*, *Paula Lewis*, and *Capt. Jim*. The old oyster house in the photograph was destroyed by a tornado in 1998. The oyster shells dropped into the shallow water from the holes in the building.

Plate 62. *Miss Lue*, Davis, 1985

Plate 63. *Clara Joyce* on rails, Straits, 2007. Famed boatbuilder Mildon Willis of Marshallberg built the *Clara Joyce* in 1946 for Earl C. Wade of Williston. The boat was made with cypress, juniper, and heart pine. Its bow is flared, like the bows made by Harkers Island boatbuilder Brady Lewis. It was named after Wade's daughters Joyce Wade Mason of Atlantic and Clara Wade Lewis of Marshallberg. Subsequently, Earl Chadwick of Marshallberg used it to fish for shrimp, clams, and oysters. The boat was photographed at the marine railway in Straits, where Mack Piggott was rebuilding it for Temple Chadwick, Earl Chadwick's son.

Plate 64. *Clara Joyce* (detail), Straits, 2007. Down East boatbuilders built "wood to wood." That is, they carefully fitted each plank to its neighbor using only a piece of cotton yarn as caulking. When the wood (pine, juniper) swelled up in water, the seal became watertight. In this detail of the *Clara Joyce* undergoing repairs, one can see the yarn emerging from the seam. The string hanging at left was originally stretched from the stem to the stern along the hull to make it easier to paint the white parts of the boat.

Plate 65. *Rambler*, Harkers Island, 2006. *Rambler* was a sink-net boat that Mildon Willis of Marshallberg built in 1935. With its low cabin with round portholes, its flared bow, and the little hatch with windows on top (frequently called the "doghouse") for the captain to steer from in bad weather, *Rambler* was similar to Harkers Island–style boats. *Rambler* was photographed at the East Bay Boatworks on Harkers Island.

Plate 66. *Jean Dale*, Harkers Island, 2007. Among the many boatbuilders in the Core Sound region, Brady Lewis of Harkers Island was one of the most famous. His innovative "flared bow" design became the defining characteristic of Harkers

Island workboats. Lewis built *Jean Dale* in 1946 for Harry Lewis of Harkers Island, who named it for his children, Patty Jean and Dale. Sink netters were distinguished from Atlantic's long-haul boats by their low cabins, flared bows, and porthole windows. In 2000, the Lewis family donated *Jean Dale* to the Core Sound Waterfowl Museum and Heritage Center on Harkers Island, where it was restored.

Plate 67. *Mary Rose*, Harkers Island, 2005. Atlantic fisherman Harry Brickhouse Jr. used *Mary Rose* for many years. The boat was sold after Brickhouse died, and it was photographed at the East Bay Boatworks on Harkers Island after his death.

Plate 68. Shrimpboat, Marshallberg, 1985

Plate 69. *Miss Miriam*, Atlantic, 2006. Carl Edwards of South River built *Miss Miriam* for the long-haul fishing trade. It draws only 30 inches of water. Nathan Spencer of Ocracoke bought it and named it after one of his daughters. Its current owner, Buddy Gaskill of Stacy, shrimps part time with it.

Plate 70. South River, 2007. South River residents say that boatbuilders Carl and Charley Edwards began building this 60-foot trawler beside their South River house in the late 1980s, but they never completed their work. After a while, trees grew up around the boat so that in summer it is barely visible from the road. Neighbors humorously call it "Noah's Second Ark." Though South River is not truly a Down East community, its boatbuilders built and repaired a lot of Down East boats.

Plate 71. Early morning haul, 2006. At dawn in early October, Danny Mason's *Haulboat* sets out on a haul in Barry's Bay. Long-hauling involves two three-man crews working two workboats and two skiffs. Long-haul captains choose places to fish depending on the season, the wind, tides, and other factors.

Plates 72, 73, & 74. Setting out, Core Sound, 2006. As *Haulboat* passes *Old Salt*, Hugh Styron Jr. in *Old Salt*'s skiff passes the staff tied to the nets to Brandon Gavetti. He will tie the nets in his skiff to the ones he receives. The fishermen will tow about three-quarters of a mile of net over 2 or 3 miles. They set out in the deep part of the sound and haul to the shallows.

Plate 75. Danny Mason aboard *Old Salt*, 2006. Danny Mason, captain of *Old Salt*, adjusts the tow cable attached to the nets. *Haulboat* is at the other end of the cable, lost in the haze of the May morning. During the course of a haul, Mason will make constant adjustments on the rope.

Plate 76. Breakfast aboard *Old Salt*, 2006

Plate 77. Buster Salter and Gerry Barrett aboard *Miss June*, 2006

Plate 78. Buddy Gaskill, Core Sound, 2006

Plate 79. Footing stake, 2006. Hugh Styron Jr. and Shane Moldenhaur work on the footing stake in rough seas during a mid-October haul at Evergreen Slough. Men work in skiffs but also get into the water in the last stages of the long-haul operation.

Plate 80. Working on the footing stake, 2006. Hugh Styron Jr., Shane Moldenhaur, Luke Salter, and Brandon Gavetti maneuver skiffs to attach a net to the footing stake. The runboat *Miss Bettie*, dispatched by the Clayton Fulcher Seafood Co. in Atlantic, appears in the background.

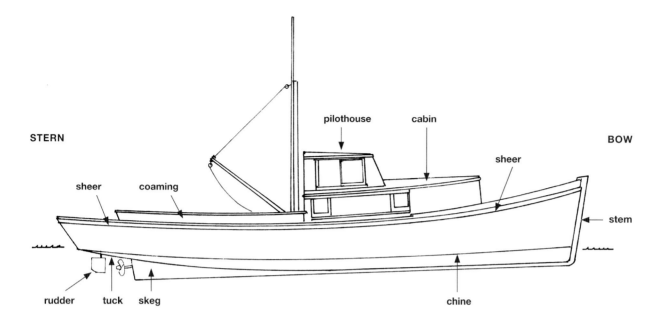

STERN

BOW

pilothouse cabin

sheer

sheer coaming

stem

rudder tuck skeg

chine

Pilothouse: The upper portion of a boat's superstructure in which the pilot steers the boat.

Pound-net fishing: Pound nets trap fish by guiding them along enclosed net walls to a "pound" at the very end. The nets are stationary in the water, staked out with saplings cut down from woodlands.

Runboat: In certain fisheries, such as the long-haul fishery, a runboat would go out to fishermen in the sounds, collect their fish, and bring them back to the fish house for sorting and packing. In times past, runboats were called "buy boats" because they bought the fish directly from the fishermen.

Sharpie: A sailing vessel introduced into Core Sound in the late 1800s that had a flat bottom planked crosswise, a round stern, and a length of about 25 to 40 feet. The sharpie was the direct ancestor of Core Sound vessels.

Sheer: Viewed from the side, the sheer is the line formed by the uppermost horizontal plank of a boat. Many Core Sound boats have a "sweeping" sheer, an exaggerated dip from fore to aft.

Sink-net fishing: A sink-net boat sets out about 500 yards of net that have a heavy lead line on the bottom and a float line on top. The fish are captured when they attempt to swim through the meshes, trapping themselves by their gills.

Skiff: A small boat from 16 to 22 feet in length.

Sou'wester: An old-fashioned oilskin hat with a long brim worn by fishermen to protect their heads from rain and weather.

Stem: The forward edge of the bow. It may also be thought of as the forward extension of the keel.

Stern: The farthest aft part of the boat.

Trawler: A large fishing boat that tows a net to catch fish or shrimp.

Tuck: The area deep under the stern where the planking fits into the sternpost.

Wind tide: Irregular tide created by wind as opposed to the regular tides caused by the gravitational forces of the moon, the sun, and the earth's rotation.

Workboat: A boat used for work, usually commercial fishing.

HULL SHAPES

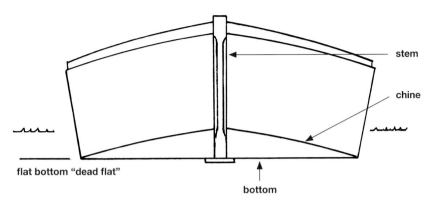

stem

chine

flat bottom "dead flat"

bottom

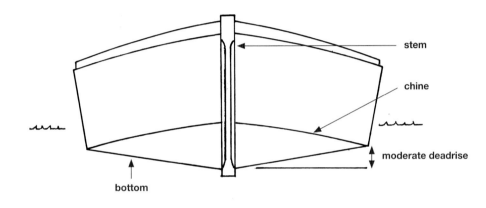

stem

chine

moderate deadrise

bottom

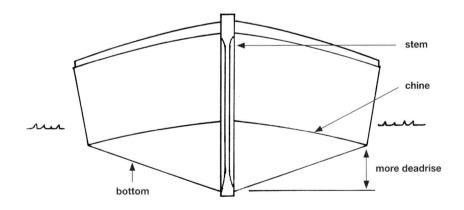

stem

chine

more deadrise

bottom

STRAIGHT-SIDED BOW

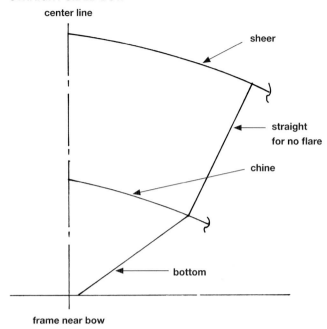

center line

sheer

straight
for no flare

chine

bottom

frame near bow

FLARED BOW

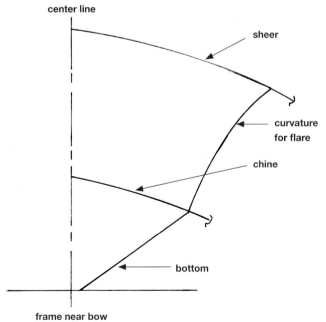

center line

sheer

curvature
for flare

chine

bottom

frame near bow

seum in Beaufort, fact-checked the glossary and illustrated the workboats found there. Ruth Little shared her work on the Hunting Quarters Primitive Baptist Church with me.

I've written previously about the workboats of Core Sound in articles that have appeared in the following publications: *Southern Cultures*, *Wildlife in North Carolina*, *Our State*, and *WoodenBoat*. Portions of the prologue appeared first in 2008 in the N.C. Humanities Council publication *Conversations*.

Galleries and museums interested in a traveling exhibit of selected photographs from this book may write the N.C. Museum of History in Raleigh, North Carolina, for information on its traveling exhibits. For updates on the "Workboats of Core Sound" project, schedules of upcoming exhibits, and instructions for buying fine art prints, see the author's website www. lawrenceearley.photoshelter.com.

About the Photography

In making the photographs in this book, I used a variety of film cameras that included 35mm, medium-format (6x7 and 6x9), and large-format (4x5). The sheer number of cameras I used may suggest I had no strategy in mind in terms of matching format to purpose, but in fact I found specific uses for all of these cameras. My Nikon F3 35mm camera and a 24mm lens were absolutely essential, at least for my eye, in getting close to the fishermen as they worked in the water and on the boats. The Fuji 6x9 and the Mamiya 6x7 cameras (mounted on a tripod, of course) were my workhorses for photographing the boats tied up at the docks, and I relied on the 4x5 large-format camera for photographing many of the landscapes where I had time to set up the camera. I used Kodak Tri-X and fine-grained Kodak T-Max 100 film in all cameras. In preparing the digital files for this book, I scanned the negatives and then worked them up in Adobe's Photoshop and Apple's Aperture programs.

It may seem odd that I used film for this project. Digital photography is standard today among many fine-art photographers seduced by the ease and beauty of digital materials. Yet when I began the project, I had been working with film cameras for thirty-five years, learning darkroom skills from workshops and the examples of master photographers whose articles, books, and prints I collected and whose photographs I sometimes traveled hundreds of miles to view. It was difficult to give up the traditional darkroom, as time-consuming as it was, for an unknown world of expensive cameras and software. Despite my reticence, I eventually purchased a used digital camera with which I produced a few images that appear in this book.

Among the many challenges a photographer faces in the Down East region is the flatness of the landscape, with few vertical elements to give relief to the unrelenting horizontality and precious few ways to get a bird's-eye view of the terrain. A friend of mine quipped that in the Down East landscape, a boat's mast becomes a mountain, the only vertical thing on the horizon. In the absence of trees, I looked for creeks or canals to lead the eye deeper into the distance and enliven the composition.

Other challenges were of the pesky and irritating sort. It didn't take long before I realized that Down East is ruled by mosquitoes. They lie in wait outside your car and instantly attack when you step out. In the time that it took to survey a site, decide where to set up the tripod, and take the picture, hundreds of the critters had beset me with evil intentions in their tiny, black hearts. A cold winter's day might warm up and wake the bad boys from their lethargy.

When a bit of breeze held the mosquitoes at bay, other insect hazards lay in wait. On one humid day behind the Smith fish house in Atlantic, I saw a gray and monotonous sky suddenly penetrated by shafts of bright sunlight that illuminated the surface of Core Sound and silhouetted a pound net strung out into the water. Realizing that the light effects would not last long, I looked for a spot that might provide a little elevation from which to photograph the spectacular scene. A low grassy "hill" next to the harbor served. The grass was wet and the surface uneven, with hidden hazards of metal and wood; but I found a spot to set up the tripod and my 4x5, and the beautiful scene lay before me (Plate 19). I threw the dark cloth over my head and began the familiar movements to compose

and focus the camera. Suddenly, my legs were burning. When I looked down, I realized that I had set up on top of a colony of fire ants. They had swarmed out of their mound and over my sneakers and had already reached the promised land of my calves, with every intention of heading on toward higher ground, much higher ground! I swatted at the fire ant assault while trying to keep the ground glass from fogging in the confined and humid space beneath the cloth. I was able to expose two sheets of film before deciding that survival trumped art, whereupon I packed up and headed down the hill, still thwacking at the biting critters.

As any explorer would, I bore the scars from that experience with pride for many months!

Index

In this index, (ill.) refers to a photograph of the subject; (cap.) refers to information about the subject in a caption or a quote.